MW00647027

John Willie's
Best of Bizarre

Cover / Umschlag / Couverture:

Original cover image from *Bizarre* Vol. 4, 1946

Ill. p. 4 / Abb. S. 4:
John Willie, "Pretty Polly" from *Bizarre* Vol. 20, p. 45, 1956

Ill., p. 18 / Abb. S. 18:
Photo of beauty in smart red rubber cape and very high heels,
from *Bizarre* Vol. 1, p. 31, 1954

Ill. p. 25 / Abb. S. 25:
Willie's full-figure watercolor of bizarre costuming, from *Bizarre*
Vol. 3, p. 16, 1946

Ill. p. 29 / Abb. S. 29:
Text the shape of a corset – two powerful women gesture to
pathetic editor "Come out – worm." Women in scanty attire stand
on the 'hips' of text pulling in, from *Bizarre* Vol. 3, p. 5, 1946

John Willie's *Bizarre* was published from 1948 to 1959 at
irregular intervals. Volume I originally appeared in 1954,
but in our reprint it has been placed in front of the subsequent
volumes

© TASCHEN GmbH
Hohenzollernring 53, D–50672 Köln
www.taschen.com

© 2001 Text by Eric Kroll, San Francisco (CA), USA
Edited by Eric Kroll
Editorial coordination by Nina Schmidt, Cologne
German translation by Gabriele-Sabine Gugetzer,
Hamburg
French translation by Philippe Safavi, Paris

Printed in Italy
ISBN 3–8228–5555–3

John Willie's
Best of

BiZARRE

Edited by Eric Kroll

TASCHEN

KÖLN LONDON MADRID NEW YORK PARIS TOKYO

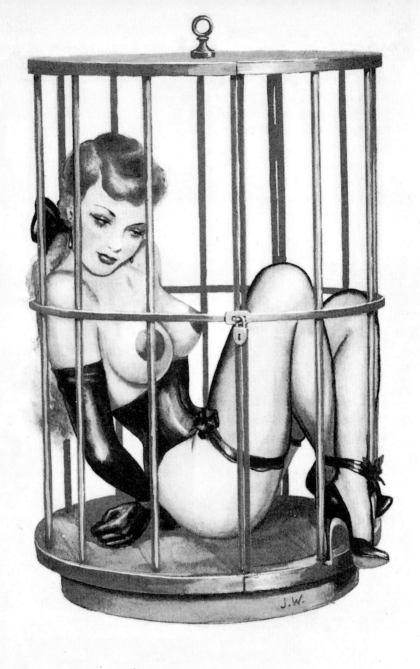

" PRETTY POLLY "

Contents
Inhalt
Sommaire

John Willie
is Bizarre

by Eric Kroll

I am writing the introduction to the long-awaited reprinting of *Bizarre* magazine. But it's really about John Alexander Scott Coutts, aka John Willie. Artist, photographer, writer, publisher and banjo player John Willie. I bow down to you. You are the Leonardo da Vinci of Fetish and maybe this publication will give you the recognition you merit.

In his life he came full circle. Born December 9, 1902, into a wealthy British merchant banking family, he was banished to Australia. He married Holly and they moved to New York City in the 1940s. He took wonderful bondage photos of the dark-haired beauty but the marriage bond disintegrated and they were divorced. He started *Bizarre* magazine in 1946 and published the first 20 issues before moving to Hollywood, California, in 1957, a bitter man. In 1961 he became ill (brain tumor) and was forced to discontinue his mail order business. He destroyed his archives and returned to England. He died on August 5, 1962. Brilliant. A great artist. A visionary. He died penniless. So what else is new?

John Willie was the MASTER. I don't think he was into extreme cruelty. He believed in consensual bondage. He seems to have been cocky. This makes sense. He knew of a world that no one else could even imagine. His vision left him alone in the world. He had a drinking problem. I can understand that. He was rejected by his family. He was constantly broke and from the way he wrote he had a nagging wife.

One of the bars he drank in was Chumley's. I've been to this notorious art bar in West Greenwich Village. It has no name out front. One either knows it or not.

Rumor had it Willie's friend bought the drinks. Sir James, owner of the Chateau in North Hollywood, a private b&d/s&m establishment, told me how Willie found his models. There was another bar in the Village that shared an entranceway with a drugstore. As one entered there was a magazine rack. Willie put a stack of his recently printed *Bizarre* magazines in the rack. From the bar he could watch as the women came in from the street. Those females that took an interest in his publication he'd approach. I've heard that the secretaries at *Bizarre* were also his models.

He liked leggy, dark-haired, small-breasted women. To Willie a model's range of expression was very important. Could she show emotion? His art and his photographs were successful because they looked real. Willie took photographs and drew from the photographs. Sir James attended several of John Willie's photo sessions in studios in Greenwich Village and

Manhattan's Westside. He claimed that Willie would do nude bondage photographs for his own private collection to draw from. Once he had drawn the body contours correctly he'd paint on the clothes. He recalled Willie photographing Betty Page. He hog-tied her, did semi-suspension bondage and even total nude bondage. Unfortunately, the armed services lost Sir James' two steamer trunks filled with bondage photos and drawings by Willie and others.

More than likely Willie met Page at Irving Klaw's studio on East 14th street. I asked Eric Stanton, the great fetish artist, if he ever met Willie. He said he saw him once come into Klaw's office – 20 feet away. He began to go over to speak to him and Irving turned to Stanton, pointed a finger and said: "Stay away!" Irving didn't want his artists to fraternize.

I read with fascination the Correspondence section in almost all the issues of *Bizarre*. People could realize they weren't alone in their "peculiar" interests. I was amazed at how many couples practised consensual bondage, "Hydrophilia" (the art of getting wet while fully clothed) and the predominance of "slaverettes" (women as masters).

So what is truth? How much of what I read is of the imagination and does it matter if it exists or is someone's fantasy? Both are extensions of the person and both trigger ideas and emotions – which is what John Willie's *Bizarre* magazines do. While reading the approximately 1,600 pages of *Bizarre* I found myself constantly jumping up to xerox a drawing or a photo, amazed at the thoughts these images provoked. Fakir Musafar, the father of modern primitivism and a friend, wrote Willie and received back letters from a 'Miss Maggie' whom he believed could have been Willie's alter ego. Eric Stanton said he heard rumors Willie enjoyed wearing silk stockings. For comfort, or was this his female side? I think Willie was a pure dominant. In a letter to Jim reprinted in Belier Press' *Sweet Gwendoline* he stated: "I've tried a corset on myself and it was nothing else but damned uncomfortable. It gives a woman a beautiful shape which I like but I shall get double pleasure out of using it as an 'instrument of correction'." In the same letter to Jim he claimed: "I don't like extreme cruelty ... I simply apply as much as is needed to correct disobedience. Discomfort in bondage helps increase the realization of helplessness." (His quest for realism.)

In volume 2 No. I of Fakir's *Body Play* magazine he speaks about meeting Willie at a bar in Minneapolis, Minnesota. "We talked about ultra high heels and we both agreed that in themselves they possessed no unique charm. However what was exciting about them was the thought that someone had to endure hours of painful training to learn to wear them."

I don't think *Bizarre*'s circulation was very big. It appeared erratically. I've never heard a logical explanation for why volume 2 came out first in 1946 and volume 1 appeared in 1954 just after volume 13. Was it a practical joke of Willie's? Just like choosing "Willie" as his pseudonym, which meant "prick" in English slang.

I know that many readers first became aware of Willie through his serialization of *Sweet Gwendoline* in *Wink* magazine in the August and October 1949 issues. Others found copies of *Bizarre* by accident. "The Manhattanite" told me he was in Boston attending Harvard University when he went to the Howard Burlesque House and stopped at the neighboring cigar store. On the rack was *Bizarre* volumes 2 and 3. He "flipped" and began writing directly to Willie. They corresponded and he visited Willie in Los Angeles in the late 1950s. Willie hired one of his favorite models, Pat, and the Manhattanite photographed her with Willie in attendance in Willie's apartment. She wore high-waisted white underwear which are a favorite fetish for the Manhattanite and me. We also both love to play golf. I don't think there is a correlation. He said Willie picked him up at the airport. He was on a business trip.

He said Willie seemed troubled and thought he was bothered by censorship and mail problems. As Bunny Yeager cloaked her fine nude photography in "How To" technical photo books, Willie in *Bizarre* magazine felt it necessary to camouflage his interest in bondage photography by using his images to advise: "'Don't let this happen to you.' Learn jiu-jitsu, the art of self-defense."

Willie seemed to enjoy intricate correspondence with his readership and would give detailed rope bondage advice including step by step sketches. His handwriting was very fine and difficult to read. He recommended the sea scouts manual for learning knots. He had been a merchant marine while living in Australia. He guarded his mailing list tightly and destroyed it when he became ill and had to close his business in 1961. He never lacked integrity in his business, art or photography.

When Willie went West

When he moved to L.A. he implied he sold or gave *Bizarre* to his secretary and her boyfriend but wasn't pleased with what they did with it. Fakir Musafar believes he sold it to Mahlon Blaine, the artist whose work appeared frequently after volume 20. Jeff Rund, in his biography of Willie in *Sweet Gwendoline*, says he sold the magazine to R.E.B. who continued to publish it until 1959.

Volume 2 was printed in Montreal, Canada, while all the others were printed in New York City. Coutts used Montreal as a mailing address. Shrewd. He wouldn't do that today. Canada frowns on bondage images. He was a poor businessman and complained constantly about high costs. Supposedly, his office in New York was ransacked and art stolen. He resented the deal he had with Irving Klaw as to *Sweet Gwendoline*. Klaw published *Sweet Gwendoline* in "The Escape Artist" and "The Missing Princess" and had Eric Stanton reluctantly paint clothes over the whip marks directly on the original art work.

John Willie and the entire sexual underground of that period (I exist pleasantly in that underbelly today) read like a Raymond Chandler detective novel filled with intrigue. Sup-

posedly he kept several residential apartments in New York City to shoot in and produce his magazine. People used initials or pseudonyms. "The Manhattanite" for example. Or "John Willie".

Conversely, it is rumored that Willie was greatly disturbed by the death of one of his models, Judy Ann Dull. She was the third victim of Harvey Glatman, the Los Angeles "Bondage Murderer". After photographing the nude women bound and gagged he'd strangle them with the same sash cord. Another Willie model, Lorraine Virgil, was to be his fourth victim but instead was able to wrestle the gun from him and hold him at gunpoint until a California highway patrolman arrived (like a Raymond Chandler novel). After "owl-eyed" television repairman Glatman confessed to the murders he brought police investigators to his old address – 5924 Melrose Avenue – where another pin-up photographer was now living.

Not the best press for a professional bondage photographer. It is said that Willie was very troubled that his photographs and art might have contributed in some way to this hedious crime. Ira Levine, current editor of *Taboo* magazine, heard rumors that Willie had had an "old man's folly" for Dull, but unfortunately, in personality, she was much like her name.

If Willie was acutely upset that his photographs and art contributed to a murder, it didn't stop him from placing an ad several years later in *Adam* magazine offering to sell a BIG, 64 page MAGAZINE CARTOON of *Sweet Gwendoline* using a close-up of Gwen's gagged face.

Well now here follow the "Icons of" the 26 issues of John Willie's *Bizarre* magazine. *Bizarre* magazine was an open forum for just that – bizarre ideas, concepts and costumes. I personally found plenty to think about and I'm certain everyone will. Simply open up your imagination and memory bank, float down the erotic stream of human consciousness and find the "bizarre" that is pleasantly within us. Willie believed it is bad to "bottle up" the bizarre which, left unexplored, can cause problems.

It's been over five years since I've looked closely at John Willie's *Bizarre*. I see myself and my own work more clearly now, particularly in the context of Willie's work. People come to me and talk about their bewilderment at all the trappings in my photographs. The stockings, the extreme heels, the tight-fitting blouses make no sense to some people. They would rather fantasize about, or make love to, a nude woman. Not me. Not John Willie. Not many many other men and women. Costuming is vital. Essential. Now, I don't know whether my obsession with erotic accoutrements came from seeing John Willie photos or drawings in my adolescence, or whether I've grown into this fascination as an adult, but costuming turns me on. And it obviously turned on the grand master John Willie.

The other thing I realize from again devouring John Willie's *Bizarre*, is how important his wife was to his early work. When I was asked to choose the "Icons Of" I kept picking the photos he had done of his wife. I understand why he used her in his work. She was most likely to understand his wonderfully twisted and out-of-the-norm mind. It was she, after hours of

working with Willie, who could interpret his direction the best. He wouldn't have to explain himself as he would to a new model, or rationalize his unusual concepts to a stranger. I understand the ease and psychic comfort of working over and over with the same person. After all, he wasn't trying to sell a new car; he was trying to illustrate or put flesh on his imagination. I have just finished a book (The Transformations of Gwen) centered around the woman I live with. She understands and doesn't question it when I suggest she 'walk' two naked men on a leash down a leafy path, dressed in heels, and vintage bra and girdle.

One new question I have about John Willie that I didn't have five years ago is this: What sort of website would he have if he were working today? Hmm. I mean, the Bizarre issues had a correspondence section ... how many emails would he get now? How large a community would he reach? Enormous, I'm certain. So maybe it's better he isn't alive today. This way, his fantastic and dirty little secrets can be kept just between us.

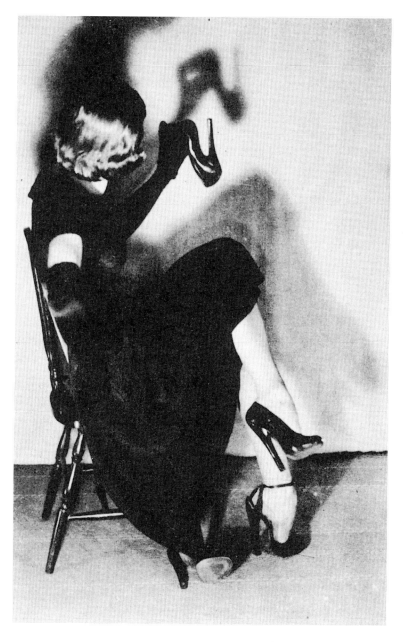

"*наbоmа*" *photo*

John Willie
ist »Bizarre«

von Eric Kroll

Ich schreibe die Einleitung zu der lang erwarteten Wiederauflage des Bizarre-Magazins. Doch eigentlich schreibe ich über John Alexander Scott Coutts alias John Willie. Künstler, Fotograf, Schriftsteller und Verleger John Willie, ich verneige mich vor dir. Du bist der Leonardo da Vinci der Fetischfotografie und vielleicht erhältst du durch diese Veröffentlichung endlich die Anerkennung, die du verdienst.

In seinem Lebenslauf schloss sich ein Kreis. Am 9. Dezember 1902 wurde er in eine wohlhabende englische Bankiersfamilie geboren, später dann nach Australien verbannt. Er heiratete Holly und zog mit ihr in den 40er Jahren nach New York. Er machte wundervolle Bondage-Fotos von dieser brünetten Beauty, doch das Band der Ehe hielt nicht und er wurde geschieden. 1946 kam Bizarre auf den Markt. Er veröffentlichte 20 Ausgaben, bevor er 1957 nach Hollywood, Kalifornien, zog, ein verbitterter Mann. 1961 erkrankte er an einem Gehirntumor und musste seinen Mailorder-Versand aufgeben. Er vernichtete sein Fotoarchiv und kehrte nach England zurück, wo er am 5. August 1962 starb. Ein großer Künstler. Ein Visionär. Bettelarm, als er starb. Noch irgendwelche Fragen?

John Willie war der MEISTER. Dass er die extrem grausame Richtung bevorzugte, glaube ich nicht. Er war Verfechter des »consensual bondage« – Du fesselst mich, und ich habe nichts dagegen. Er scheint anmaßend gewesen zu sein und das ist verständlich, denn er wusste von einer Welt, die sich niemand sonst auch nur vorstellen konnte. Er hatte Alkoholprobleme. Das kann ich nachvollziehen. Seine Familie hatte sich von ihm abgewandt. Er war ständig pleite und nach dem zu urteilen, was er über seine Frau schrieb, hatte er einen nörgelnden Besen zu Hause.

Zu seinen Stammkneipen gehörte das »Chumley's«. Ich habe mir diese berüchtigte Künstlerkneipe im westlichen Greenwich Village einmal angeguckt. An der Tür steht kein Name. Entweder kennt man den Laden oder nicht.

Gerüchten zufolge wurde Willie von seinen Freunden freigehalten. Sir James, dem in North Hollywood das »Chateau« gehörte, ein Privatclub für Liebhaber von Fesseleien und Sado-Maso-Spielen, erzählte mir einmal, wie Willie seine Modelle fand. In Greenwich Village gab es damals eine Bar, die sich den Eingang mit einem Drugstore teilte, wo man neben Arzneimitteln auch Kaugummis, Zigaretten und Zeitschriften bekam. Gleich am Eingang stand ein Ständer für Zeitschriften und dort deponierte Willie die neuesten Ausgaben von Bizarre. Dann setzte er sich in

der Bar an die Theke und beobachtete die Frauen, die den Drugstore betraten. Hatte er das Gefühl, sie interessierten sich für *Bizarre*, dann sprach er sie an. Auch die Sekretärinnen von *Bizarre*, so habe ich gehört, standen ihm Modell.

Er mochte Brünette mit kleinen Brüsten und langen Beinen. Wichtig war für ihn die Ausdruckskraft eines Models: Konnte es Emotionen darstellen? Seine Kunst und seine Fotos waren deshalb so erfolgreich, weil sie immer echt wirkten. Willie machte Fotos und seine eigenen Fotos inspirierten ihn dann bei seinen weiteren Arbeiten. Sir James nahm an mehreren solcher Fotosessions von John Willie in Greenwich Village und der Manhattan Westside teil. Er behauptete, Willie hätte nackte Bondage-Fotos für seine Privatsammlung gemacht, um dann mit ihnen zu arbeiten. Erst wurden die Körperkonturen nachgezeichnet und danach malte er den Körpern Kleidung an. Sir James erinnerte sich auch, wie Willie einmal Betty Page fotografierte. Betty wurde in allen denkbaren Stellungen abgelichtet, sogar nackt und an allen Vieren gefesselt. Leider verschlampte die Armee zwei Überseekoffer von Sir James mit Bondage-Fotos und Zeichnungen von Willie und anderen.

Es ist wahrscheinlich, dass Willie Betty Page im Fotostudio von Irving Klaw in der 14. Straße in der Manhattan Eastside kennen gelernt hat. Ob er Willie je begegnet sei, fragte ich den genialen Fetischkünstler Eric Stanton. Ja, er habe ihn mal aus sechs Metern Entfernung in Klaws Studio kommen sehen. Er sei auf ihn zugegangen, um sich bekanntzumachen, aber Irving habe sich direkt umgedreht, mit dem Finger gedroht und gesagt:»Bleib, wo Du bist«. Klaw schätzte es nicht, wenn sich seine Künstler untereinander zu gut verstanden.

Faszinierend fand ich die Leserbrief-Rubrik in fast allen Ausgaben von *Bizarre*. Sie gab den Leuten das Gefühl, mit ihren»speziellen« Interessen nicht alleine dazustehen. Ich war überrascht, dass so viele Paare einvernehmliche Fesselpraktiken oder»Hydrophilie« (die Kunst, nass zu werden, während man vollständig bekleidet ist) betrieben. Auch die Vorherrschaft von»Slaverettes« (wenn die Damen zu Herren werden) überraschte mich.

Was ist dann also wirklich die Wahrheit? So viel bei meiner Lektüre entspringt der Fantasie. Ist es denn so wichtig, ob etwas wirklich existiert oder ob es einfach der Fantasie eines anderen entspringt? Beides gehört als legitime Weiterentwicklung zu einer Person und beides gebiert Ideen und Gefühle. Genau das tun auch die *Bizarre*-Ausgaben von John Willie. Während ich die ungefähr 1600 Seiten von *Bizarre* las, fand ich mich ständig am Fotokopierer wieder und vervielfältigte Zeichnungen und Fotografien, überrascht von den Gedankengängen, die diese Bilder bei mir auslösten. Fakir Musafar, der Vater des modernen Primitivismus und ein Freund, schrieb an Willie und erhielt Briefe zurück von einer»Miss Maggie«, die, so glaubt er, Willies Alter Ego gewesen sein könnte. Eric Stanton hatte Gerüchte gehört, denen zufolge Willie gerne Seidenstrümpfe trug – als Trost oder um seiner weiblichen Seite Ausdruck zu verleihen? Ich halte Willie ganz eindeutig für einen dominanten Charakter. In einem Brief an Jim, der in *Sweet Gwendoline* (von Belier Press) neu abgedruckt wurde, erklärt er:

»Ich habe selbst ein Korsett ausprobiert und fand es einfach nur extrem unbequem. Einer Frau verleiht es eine wunderbare Silhouette, die ich sehr schätze, aber noch mehr Vergnügen wird es mir bereiten, es als ›Züchtigungsinstrument‹ einzusetzen. Ich wende immer nur so viel Züchtigung an, wie vonnöten ist, um Ungehorsam zu zähmen. Das Gefühl des Unbehagens beim Bondage-Akt verstärkt das Gefühl der Hilflosigkeit.« Sein Streben nach Realismus.

In Ausgabe Nummer 2 seines *Body Play*-Magazins spricht Fakir über sein Zusammentreffen mit Willie in einer Bar in Minneapolis, Minnesota. »Es ging um ultrahohe Stilettoabsätze, die für uns beide an sich keinen besonderen Reiz darstellten. Reizvoll war an ihnen nur der Gedanke, dass jemand lange, schmerzvolle Stunden der Übung hinter sich hatte, um auf ihnen laufen zu lernen.«

Dass *Bizarre* je eine hohe Auflage erreichte, kann ich mir nicht vorstellen. Es kam unregelmäßig auf den Markt. Ich habe auch nie eine logische Erklärung dafür erhalten, warum Heft 2 im Jahr 1946 erschien und Heft 1 im Jahr 1954 – gleich nach Heft 13. War das ein typischer Willie-Witz? So, wie »Willie« als Pseudonym zu wählen? Denn das ist ein Slangwort für »Schwanz«.

Viele Leser wurden durch seine Fortsetzungsgeschichte von *Sweet Gwendoline* in den August- und Oktoberausgaben von *Wink* im Jahr 1949 erstmals auf Willie aufmerksam. Andere stießen durch Zufall auf seine Magazine. Der Manhattanite erzählte mir, er sei während eines Aufenthalts in Boston an der Harvard-Universität mal im Howard Burlesque House gewesen und habe in einem Zigarettenladen in der Nähe Heft 2 und 3 von *Bizarre* im Zeitschriftenregal entdeckt. Er sei regelrecht »ausgeflippt« und habe sofort einen Briefwechsel mit Willie begonnen. In den späten 50er Jahren habe er ihn dann in Los Angeles besucht. Willie orderte Pat, eines seiner Lieblingsmodelle, und der Manhattanite fotografierte sie in Willies Apartment – mit ihm im Schlepptau. Pat trug weiße hochtaillierte Unterwäsche – ein Fetischfavorit sowohl von mir als auch vom Manhattanite. Auch auf anderem Gebiet haben wir den gleichen Geschmack: Wir spielen beide gerne Golf. Doch ich glaube nicht, dass da ein ursächlicher Zusammenhang besteht. Willie habe ihn damals am Flughafen abgeholt, erinnert sich der Manhattanite. Er sei auf Geschäftsreise gewesen.

Willie habe den Eindruck erweckt, in Schwierigkeiten zu stecken und er schien Probleme mit der Zensur und der Postzustellung zu haben. So wie Bunny Yeager ihre sehr ordentliche Aktfotografie in Büchern der Art von »Wie fotografiere ich richtig« versteckte, fühlte sich Willie bei seinem Magazin *Bizarre* dazu genötigt, sein Interesse an Bondage-Fotografie zu verschleiern und seinen Bildern einen abschreckenden Ton zu verleihen: »DAS sollte Ihnen nicht passieren. Lernen Sie Jiu-Jitsu, die Kunst der Selbstverteidigung.«

Willie schien Freude an komplexer Korrespondenz mit seiner Leserschaft zu haben und gab detailliert Auskunft zum Thema Bondage nebst Zeichnungen, die die einzelnen Schritte

erläuterten. Seine Handschrift war vornehm und schwer zu lesen. Er empfahl die Handbücher der Marine, um das richtige Knoten von Fesseln zu lernen. Während seines Aufenthalts in Australien hatte er bei der Handelsmarine gearbeitet. Seinen Postverteiler hütete er wie seinen Augapfel und vernichtete ihn, als er sich 1961 aus Krankheitsgründen aus dem Berufsleben zurückzog. Es mangelte ihm niemals an Integrität, weder auf geschäftlicher Ebene noch in der Kunst oder Fotografie.

Willie erkundet den Westen

Offenbar hatte er *Bizarre* nach seinem Umzug nach Los Angeles an seine Sekretärin und deren Freund verkauft oder ihnen überschrieben, doch schien er nicht glücklich über die Entwicklung des Blattes unter deren Ägide zu sein. Fakir Musafar ist der Meinung, er habe *Bizarre* an den Künstler Mahlon Blaine verkauft, dessen Arbeiten nach Heft 20 häufig erschienen. In seiner Biografie von Willie in *Sweet Gwendoline* behauptet Jeff Rund, er habe sein Magazin an R.E.B. verkauft, der es noch bis 1959 verlegte.

Mit Ausnahme von Heft 2, das in Montreal, Kanada, gedruckt wurde, wurden alle Ausgaben in New York gedruckt. Coutts gab Montreal als Postadresse an. Das könnte er heutzutage nicht mehr machen. In Kanada schätzt man Fesseleien nicht besonders. Zum Geschäftsmann taugte er nicht und beklagte auch ständig die hohen Unkosten. Anscheinend wurde sein New Yorker Büro durchwühlt und während der Plünderung kamen Kunstgegenstände abhanden. Über den Vertrag, den er mit Irving Klaw für *Sweet Gwendoline* eingegangen war, war er selbst ärgerlich. Klaw veröffentlichte sie in *The Escape Artist* und *The Missing Princess* und ließ einen zögerlichen Eric Stanton die auf dem Original sichtbaren Peitschenstriemen durch aufgemalte Kleidungsstücke abdecken.

John Willie und überhaupt der ganze »Sex-Underground« (in dessen Bauch ich es mir heute eingerichtet habe) der damaligen Zeit lesen sich wie ein Raymond-Chandler-Krimi voller Heimlichkeiten und Machenschaften. Er hatte wohl mehrere Apartments in New York, die als Wohnraum angemietet worden waren, von ihm jedoch als Fotostudio und zur Produktion der Hefte genutzt wurden. Man verwendete Pseudonyme »The Manhattanite« beispielsweise oder eben »John Willie«.

Willie schien, Gerüchten zufolge, von dem Tod eines seiner Modelle, Judy Ann Dull, sehr mitgenommen worden zu sein. Sie war das dritte Opfer von Harvey Glatman, dem »Bondage-Mörder« von Los Angeles. Nachdem Glatman die nackten Frauen gefesselt und geknebelt fotografiert hatte, erdrosselte er sie mit der gleichen Schnur. Lorraine Virgil, die Willie ebenfalls Modell stand, sollte sein viertes Opfer werden, doch es gelang ihr, ihm die Pistole zu entreißen und ihn damit in Schach zu halten, bis ein Verkehrspolizist eintraf. Wie aus einem Raymond-Chandler-Krimi. Nachdem »Eulengesicht« und Fernsehmonteur Glatman die ihm zur Last gelegten Morde gestanden hatte, führte er die Polizeibeamten zu seiner früheren

Wohnung – 5924 Melrose Avenue –, die wieder von einem Pin-Up-Fotografen bewohnt wurde.

So etwas liefert einem Bondage-Fotografen nicht gerade die beste Presse. Willie, so sagt man, war damals sehr besorgt, dass seine Fotos und seine Kunst in irgendeiner Weise zu diesem abscheulichen Verbrechen beigetragen haben könnten. Ira Levine, jetziger Herausgeber von *Taboo*, kannte Gerüchte, denen zufolge Willie bei Dull seinen zweiten oder dritten Frühling erlebte, doch leider war die Dame wie ihr Name, »dull« (langweilig).

Falls Willie tatsächlich erschüttert darüber war, dass seine Fotos und seine Kunst auf irgendeine Weise zu diesem Mord geführt hatten, hielt ihn das jedoch nicht davon ab, einige Jahre später im Magazin *Adam* den Verkauf eines großen, 64-seitigen Magazincartoons von *Sweet Gwendoline* mit einer Nahaufnahme einer geknebelten Gwen zu inserieren.

Also, Vorhang auf für diese Auswahl aus 26 Ausgaben von John Willies *Bizarre*. Das Magazin war ein offenes Forum für genau das – bizarre Ideen, Konzepte, Kleidung. Ich jedenfalls habe viele Denkanstöße erhalten und glaube, das wird jedem so gehen. Man muss nur seiner Fantasie freien Lauf lassen und das »Bizarre« entdecken, das sich gemütlich in jedem von uns eingerichtet hat. Willie glaubte, dass es schlecht sei, das Bizarre im Menschen zu ignorieren. So könne es Schaden anrichten.

Vor fünf Jahren habe ich mich zum letzten Mal mit John Willies *Bizarre* beschäftigt. Mittlerweile verstehe ich mich und meine eigenen Arbeiten besser, besonders im Kontext mit denen von John Willie. Ich werde oft auf die Ausstattung meiner Arbeiten angesprochen: Die Strümpfe, die extrem hohen Absätze, die eng anliegenden Blusen sind Objekte, die nicht jeder, der meine Arbeiten betrachtet, versteht. Sie möchten Frauenakte sehen oder in meinen Fotografien ihre Liebesfantasien mit einer unbekleideten Frau ausleben. Das ist jedoch nicht das, worum es mir geht. Oder John Willie. Oder vielen anderen Männern und Frauen. Was jemand trägt, ist von großer Bedeutung. Ob meine Faszination für erotische Kleidung dem Einfluss von John Willies Fotografien zuzuschreiben ist oder meinen Zeichnungen aus Teenagertagen, oder ob ich erst als Erwachsener auf den Geschmack gekommen bin, weiß ich nicht zu sagen. Doch die Be- oder Verkleidung eines erotischen Bilds erregt mich, so wie sie auch den großen Meister John Willie erregt hat.

Noch etwas anderes fiel mir beim gierigen Verschlingen seiner Arbeiten auf – wie wichtig seine eigene Frau in John Willies Frühwerk ist. Ich wurde um die Auswahl dieser »Icons« gebeten und bei dieser Auswahl fiel mir auf, dass ich mich auf Fotografien von seiner Frau zu konzentrieren schien. Ich verstehe, warum er sie zu seinem Model gemacht hat. Mehr als jede andere Person verstand sie sein wundervoll verdrehtes und völlig jenseits der Norm liegendes Wesen und konnte nach Stunden während der Sitzungen seinen Regieanweisungen am besten Folge leisten. Im Gegensatz zu einem Model, mit dem er vorher noch nicht gearbeitet hatte, musste sich John Willie seiner Frau gegenüber nicht erklären oder seine ungewöhnlichen

Konzepte gar einem Fremden gegenüber rational darstellen. Die Entspanntheit und Leichtigkeit, der psychologische Wohlfühlfaktor bei einer Arbeit mit der gleichen Person sind Aspekte, die ich sehr gut verstehe. Er wollte mit seinen Fotografien ja keine Autos an den Mann bringen. Er wollte seine Fantasien illustrieren und sie mit Fleisch zum Leben erwecken. Gerade habe ich selbst die Arbeiten zu einem neuen Buch (*The Transformations of Gwen*) abgeschlossen, die sich ebenfalls mit einer vertrauten Frau beschäftigen, nämlich der, mit der ich zusammenlebe. Sie versteht. Sie hinterfragt nicht, wenn ich sie bitte, zwei nackte Männer auf einem blätterbedeckten Pfad an der Leine »auszuführen« und dabei hochhackige Schuhe und einen altmodischen Büstenhalter und Hüfthalter zu tragen.

Ein ganz anderer Aspekt hat sich erst in den vergangenen fünf Jahren aufgetan: Ich frage mich, wie wohl John Willies Webseite ausgesehen hätte, würde er heute noch arbeiten. Mhm. Die Frage ist naheliegend; immerhin gab es im Magazin *Bizarre* auch eine Korrespondenzseite. Wie viele E-Mails würde er heute wohl bekommen? Wie groß wäre die Gemeinschaft derer, die er erreichen würde? Wahrscheinlich riesig, da bin ich mir ganz sicher. Vielleicht ist es deswegen auch besser, dass er nicht mehr lebt. Denn auf diese Weise ist sichergestellt, dass seine fantastischen und schmutzigen kleinen Geheimnisse zwischen uns gewahrt bleiben.

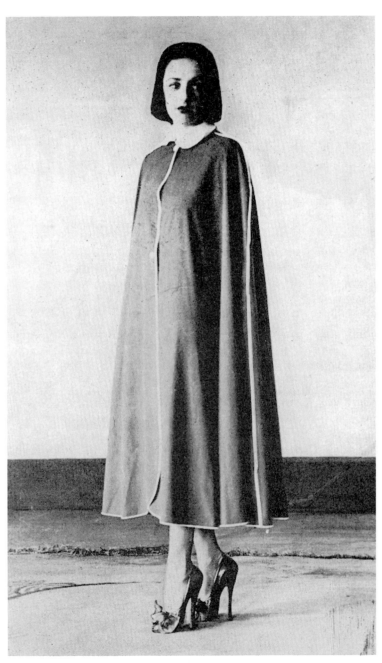

A smart red rubber cape

John Willie
est bizarre

par Eric Kroll

Je suis en train de rédiger la préface de la réédition tant attendue de la revue *Bizarre*. Mais il s'agit surtout de John Alexander Scott Coutts, alias John Willie, artiste, photographe, écrivain, éditeur et joueur de banjo. J.W., je m'incline devant toi. Tu es le Léonard de Vinci du fétichisme et j'espère que cette publication t'apportera enfin la reconnaissance que tu mérites.

 Sa vie a décrit une boucle complète. Né le 9 décembre 1902 dans une famille de riches banquiers d'affaires anglais, il fut forcé de s'expatrier en Australie. Là, il épousa Holly, avec laquelle il s'installa à New York dans les années 40. Il réalisa de merveilleuses photos SM (sadomasochistes) de cette beauté brune, mais les liens sacrés du mariage se dénouèrent bientôt et se soldèrent par un divorce. En 1946, il lança la revue *Bizarre*. Il en était au 20ème numéro lorsqu'il emménagea à Hollywood en 1957, un homme amer. En 1961, il tomba malade (une tumeur au cerveau) et dut interrompre son affaire de vente par correspondance. Il détruisit ses archives et retourna en Angleterre, où il mourut le 5 août 1962. C'était un homme brillant. Un grand artiste. Un visionnaire. Il est mort sans le sou. Toujours la même histoire !

 John Willie était le MAITRE. Je ne pense pas qu'il se soit adonné à la cruauté extrême. Il croyait aux jeux sexuels avec consentement mutuel. Il paraît qu'il était arrogant. Cela n'a rien d'étonnant. Il connaissait un univers que personne d'autre ne pouvait imaginer. Sa vision le condamnait à la solitude. Il buvait. Je peux le comprendre. Il était rejeté par sa famille. Il était constamment fauché et, à en juger par ses écrits, sa femme était une mégère.

 Chumley était l'un de ses bars de prédilection. Je connais ce rendez-vous d'artistes notoire dans l'ouest de Greenwich Village. Aucune enseigne ne permet de le distinguer de la rue, seuls les initiés savent le trouver.

 D'aucuns disent que c'étaient les amis de Willie qui lui payaient à boire. Sir James, propriétaire du Château à North Hollywood, un établissement « Bondage »-SM, m'a raconté comment il dénichait ses modèles. Il y avait un autre bar dans Greenwich Village qui avait une entrée commune avec un drugstore. Willie plaçait plusieurs copies de la dernière édition de *Bizarre* dans un présentoir à l'entrée puis allait s'asseoir dans le bar, afin de pouvoir observer les femmes qui entraient dans le magasin. Lorsque l'une d'elles semblait s'intéresser à sa revue, il l'abordait. J'ai aussi entendu dire que ses secrétaires lui servaient également de modèles.

Il aimait les brunes aux longues jambes et aux petits seins. Il attachait une grande importance à l'expressivité de ses modèles. Elles devaient pouvoir exprimer des émotions. Ses dessins et ses photos étaient réussis parce qu'ils paraissaient réels. Willie prenait des photos, puis s'en servait comme base pour ses dessins. Sir James a assisté à plusieurs séances de pose dans des studios à Greenwich Village et dans le Westside de Manhattan. Selon lui, Willie faisait des photos de nu SM pour sa propre collection et les dessinait ensuite. Après avoir calqué le contour des corps avec application, il leur peignait des habits. Il se souvenait d'une série de prises de vue avec Betty Page. Willie l'a photographiée les poignets attachés aux chevilles, à demie suspendue et même ligotée entièrement nue. Malheureusement, les forces armées ont perdu les deux malles de Sir James, remplies de photos et de dessins de Willie et d'autres.

Willie a probablement rencontré Betty Page dans le studio d'Irving Klaw sur East 14th Street. J'ai demandé à Eric Stanton, le grand artiste fétichiste, s'il avait eu l'occasion de le voir. Il m'a dit l'avoir aperçu une fois entrant dans le bureau de Klaw. Il a voulu s'approcher pour lui parler, mais Klaw s'est tourné vers lui, a pointé un doigt dans sa direction et lui a lancé : « Va-t'en ». Klaw n'aimait pas que ses artistes fraternisent.

J'ai lu avec fascination le « Courrier des lecteurs » de pratiquement tous les numéros de *Bizarre*. Tout un tas de gens découvraient qu'ils n'étaient pas seuls à partager ce goût « singulier ». J'ai constaté avec stupéfaction combien de couples pratiquaient le SM consensuel et l'hydrophilie (l'art de se mouiller tout habillé), ainsi que la prédominance des « négrières » (des maîtresses).

Mais qu'est-ce que la vérité ? Quelle est la part de l'imaginaire dans ce que je lis ? Quelle importance si les faits sont réels ou relèvent du fantasme ? Dans les deux cas, il s'agit d'extensions de la personne et tous deux suscitent idées et émotions. C'est précisément ce que font les revues de John Willie. Pendant que je lisais les quelque 1600 pages de *Bizarre*, je n'arrêtais pas de courir à la photocopieuse pour copier tantôt un dessin tantôt une photo, stupéfait par les pensées que ces images éveillaient en moi. Fakir Musafar, le père du primitivisme moderne et un ami, écrivait à Willie et recevait en retour des lettres d'une certaine « Miss Maggie » qui, selon lui, était l'alter ego de Willie. Eric Stanton m'a fait part de rumeurs selon lesquelles Willie aimait porter des bas de soie. Pour le confort ou était-ce son côté féminin ? A mon sens, Willie était un dominateur pur et dur. Dans une lettre à Jim rééditée dans le *Sweet Gwendoline* de Belier Press, il déclare : « J'ai essayé un corset et n'ai éprouvé rien d'autre qu'un inconfort extrême. Il donne à la femme une belle silhouette et, dorénavant, j'aurai doublement plaisir à l'utiliser comme un "instrument de correction". » Un peu plus loin dans cette même lettre, il ajoute : « Je n'aime pas la cruauté extrême, je n'y ai recours qu'à petites doses et uniquement pour corriger la désobéissance. Dans les rapports de maître à esclave, l'inconfort aide à accroître la conscience de sa vulnérabilité. » (Sa quête du réalisme).

Dans le premier chapitre du volume 2 de la revue *Body Play* de Fakir Musafar, Fakir raconte avoir rencontré Willie dans un bar de Minneapolis, dans le Minnesota. « Nous avons parlé de talons ultra hauts et nous sommes convenus qu'ils n'avaient aucun charme en eux-mêmes. En revanche, rien n'est plus excitant que d'imaginer les heures de torture que l'on doit subir pour apprendre à marcher avec eux. »

Je ne crois pas que *Bizarre* ait jamais eu un grand tirage. La revue sortait de manière fantaisiste. Je n'ai jamais obtenu d'explication rationnelle quant au fait que le numéro 2 soit paru en 1946 et le numéro 1 en 1954, juste après le numéro 13. Etait-ce une farce de Willie ? Tout comme d'avoir choisi « Willie » comme pseudonyme (qui signifie « bite » en argot britannique).

Beaucoup de lecteurs ont découvert Willie grâce à la parution de *Sweet Gwendoline* sous forme de feuilleton dans les numéros d'août et d'octobre 1949 de la revue *Wink*. D'autres sont tombés sur ses publications par hasard. Le « Manhattanite » m'a raconté qu'un jour, il était alors étudiant à Harvard à Boston, il s'est rendu au Howard Burlesque House. En chemin, il s'est arrêté chez un marchand de cigares situé à deux pas. Les numéros 2 et 3 de *Bizarre* étaient sur le présentoir. Il a « flashé » et a aussitôt écrit à Willie. Tous deux ont entamé une correspondance. Vers la fin des années 50, le Manhattanite a rendu visite à Willie à Los Angeles. Willie a engagé Pat, un de ses modèles favoris, et le Manhattanite l'a photographiée dans l'appartement de Willie en présence de ce dernier. Elle portait une culotte montante blanche, l'un des fétiches préférés du Manhattanite et de moi-même. Nous partageons également une passion pour le golf. Je ne pense pas qu'il y ait un lien entre les deux. Il m'a raconté que Willie était venu le chercher à l'aéroport. Il était en voyage d'affaires.

Il m'a également dit que Willie avait l'air préoccupé et que, selon lui, il avait des ennuis avec la censure et les services postaux. Tout comme Bunny Yeager, qui publiait ses belles photos de nu dans des manuels du genre « La photographie en dix leçons », dans *Bizarre*, Willie se sentait obligé de camoufler son intérêt pour la photo SM sous des légendes telles que « Faites en sorte que cela ne vous arrive pas : apprenez le Jiu Jitsu, l'art de l'autodéfense ».

Willie semble avoir développé une intense correspondance avec ses lecteurs et leur fournissait des conseils détaillés sur les mille manières d'attacher les liens, fournissant même des graphiques étapes par étapes. Son écriture était très fine et difficile à lire. Pour apprendre à faire les nœuds, il recommandait le manuel des scouts marins. (Il avait travaillé dans la marine marchande en Australie). Il veillait jalousement sur la liste de ses abonnés et la détruisit quand il tomba malade et dut fermer boutique en 1961. En affaires, en art et en photographie, il se montra toujours d'une grande intégrité.

Et Willie mit le cap sur l'ouest

Lorsqu'il emménagea à Los Angeles, il laissa entendre qu'il avait vendu ou donné *Bizarre* à sa secrétaire et son petit ami mais qu'il n'était pas content de ce qu'ils en avaient fait. Fakir

Musafar pense qu'il l'a vendue à Mahlon Blaine, l'artiste dont les œuvres apparaissent fréquemment à partir du numéro 20. Dans sa biographie de Willie dans *Sweet Gwendoline*, Jeff Rund affirme qu'il a vendu la revue à R.E.B., qui a continué à la publier jusqu'en 1959. Le numéro 2 fut publié à Montréal, et les numéros suivants à New York. Coutts utilisait Montréal comme adresse postale. Foutu ! Aujourd'hui, il ne pourrait plus en faire autant. Le Canada ne regarde pas d'un très bon œil les images SM. Il n'était pas très doué pour les affaires et se plaignait sans cesse des hauts coûts de fabrication. Il semblerait que son bureau de New York ait été « visité » et qu'on lui ait volé des œuvres d'art. Il regrettait amèrement l'accord qu'il avait conclu avec Irving Klaw quant à *Sweet Gwendoline*. Klaw publia *Sweet Gwendoline* dans « The Escape Artist » et dans « The Missing Princess ». Il demanda à Eric Stanton de cacher les marques de fouet en peignant des vêtements directement sur les œuvres originales. Stanton s'exécuta à contrecœur.

Lorsqu'on se penche sur John Willie et l'ensemble de l'underground sexuel de l'époque (je suis heureux d'appartenir à ces bas-fonds aujourd'hui), on se croirait dans un de ces polars remplis d'intrigues de Raymond Chandler. Willie avait apparemment plusieurs appartements à New York qu'il utilisait pour ses prises de vue et concevoir sa revue. Les gens utilisaient des initiales ou des pseudonymes, comme le « Manhattanite » ou « John Willie ».

De même, Willie aurait été profondément choqué par la mort d'un de ses modèles, Judy Ann Dull. Elle fut la troisième victime de Harvey Glatman, le « Tueur SM de Los Angeles ». Glatman photographiait des femmes nues ligotées et bâillonnées, puis les étranglait en utilisant toujours le même cordon de fenêtre à guillotine. Un autre des modèles de Willie, Lorraine Virgil, faillit être sa quatrième victime. Elle parvint à lui arracher son revolver et le tint en joue jusqu'à l'arrivée d'un motard de la police californienne (encore un roman à la Raymond Chandler). Après avoir avoué ses crimes, Glatman, un réparateur de télévision aux yeux « de hibou », conduisit la police à son ancienne adresse – 5924 Melrose Avenue – où habitait désormais un autre photographe de charme.

Pour un photographe professionnel de SM, ce n'était pas la meilleure des publicités. Il semblerait que Willie ait été très perturbé par l'idée que ses œuvres puissent avoir contribué d'une manière ou d'une autre à ces crimes odieux. Ira Levine, éditeur de la revue *Taboo*, a entendu dire que Willie s'était entiché de Dull, mais que malheureusement la jeune femme était aussi ennuyeuse que son nom le laissait entendre (« dull » signifiant « terne » en anglais).

Willie fut peut-être bouleversé par le fait que ses photos et ses dessins aient contribué à un meurtre, mais cela ne l'empêcha pas de placer une publicité dans le magazine *Adam* quelques années plus tard en proposant une GRANDE BANDE DESSINEE de 64 pages de *Sweet Gwendoline*, accompagnée d'un gros plan du visage bâillonné de l'héroïne.

Voici donc les « Icônes » des 26 numéros de la revue *Bizarre* de John Willie. Comme son nom l'indique, *Bizarre* était un forum ouvert sur les idées, les concepts et les costumes

bizarres. Personnellement, j'y ai trouvé matière à réfléchir et je suis certain qu'il en ira de même pour tous ses lecteurs. Ouvrez grand votre imagination et votre mémoire, laissez-vous bercer par le flot érotique de la conscience humaine et découvrez avec plaisir le « bizarre » qui est en vous. Willie croyait qu'il était mauvais de réprimer le bizarre qui, s'il n'était pas exploré, se retournait contre soi.

Voilà cinq ans à présent que j'ai examiné attentivement *Bizarre*, de John Willie. Aujourd'hui, j'ai une vision plus claire de moi-même et de mon travail, notamment avec l'œuvre de Willie en perspective. Les gens viennent me voir pour me dire combien tous les accessoires dans mes photos les sidèrent. Pour certains, les bas, les talons vertigineux, les blouses moulantes n'apportent rien. Ils préfèrent fantasmer sur une femme nue ou faire l'amour avec elle. Pas moi. Pas John Willie. Pas une quantité innombrable d'hommes et de femmes. Le costume est vital. Essentiel. J'ignore si mon obsession pour les accoutrements érotiques me vient d'avoir vu les photos et les dessins de John Willie pendant mon adolescence ou si j'ai développé cette fascination à l'âge adulte, mais les déguisements m'excitent. Et ils excitaient manifestement le grand maître John Willie.

En dévorant à nouveau les numéros de *Bizarre*, je me rends compte également de l'importance de sa femme dans ses premières œuvres. Quand on m'a demandé de choisir les « Icônes » pour *Bizarre*, je retombais toujours sur les photos qu'il avait prises d'elle. On comprend pourquoi il préférait travailler avec elle. Elle était probablement la plus à même de saisir son esprit merveilleusement tordu et hors norme. C'était elle qui, après avoir travaillé pendant des heures avec lui, pouvait au mieux interpréter ses instructions. Il n'avait pas besoin de s'expliquer comme il aurait eu à le faire avec un nouveau modèle, ni à rationaliser ses concepts inhabituels devant des inconnus. Après tout, il ne cherchait pas à vendre une voiture, mais à illustrer ou à donner chair aux produits de son imagination. Je viens de terminer un livre (*Les Transformations de Gwen*) sur la femme avec qui je vis. Elle comprend au quart de tour et ne pose pas de questions quand je lui demande de « promener » deux hommes nus en laisse sur une allée couverte de feuilles mortes, en talons aiguilles, soutien-gorge et corset anciens.

En relisant *Bizarre*, il me vient à l'esprit une question que je ne me posais pas il y a cinq ans : quel genre de site web Willie aurait-il aujourd'hui ? Hummm… Après tout, les numéros de *Bizarre* comportaient une rubrique « le courrier des lecteurs ». Combien de e-mail recevrait-il ? Combien de gens toucherait-il ? Un nombre incalculable, j'en suis sûr. Finalement, il vaut peut-être mieux qu'il ne soit plus de ce monde. Comme ça, ses petits secrets géniaux et honteux restent entre nous.

Bizarre Highlights

Selected by Eric Kroll

Bizarre **Vol. 1** (1954)

The cover shows a magnificent black and white, perfectly composed photo of a woman examining the heels of her black-laced boots. Note the extra heels in casual disarray.

Inside front cover photo: (Willie's wife?) Holly holding shoes with 12" heels that frame her dark lips. The power of the image is in her attitude.

PAGE 4: John Willie's sketches of women mimicking men's wear.

PAGES 26–27: Centerfold of Holly on her back smoking, black kid gloves, boots, exposed garters and an extra pair of heels near her head. Dark eyebrows and lips. The confidence in her eyes is compelling.

PAGE 33: John Willie's illustration of riding mistress with bull whip, spurs on heels & skin-tight dark pants and white top.

PAGE 35: John Willie watercolor of two beautiful high fashion female amputees in pencil – thin high heels and skin-tight gowns.

PAGE 49: John Willie watercolor of the lady in *Hobble Skirt*, wide brim hat and heels.

Bizarre **Vol. 2** (1946)

Cover shows Willie's humor and fantasy. Ring master with whip in black leather corset, gloves & laced boots with red high heels controls toy tiger.

PAGE 5: Fine watercolor of maid lacing her mistress into corset using her knee.

PAGE 9: Holly against seamless paper wearing a short, black, very tight skirt and knee-length black kid button boots.

PAGE 33: A beauty in riding jodphurs, riding boots with extreme heels and crop. Her back is to the camera and the riding crop just below her arse. Her toothy inviting smile is wonderful. Her features are like a Willie watercolor.

Bizarre **Vol. 3** (1946)

Cover is whimsical with John Willie as designer devil. Are those fig leaves on the floor?

PAGES 19, 20, 30: Willie's full-figure watercolors of bizarre costuming. My personal favorites are *The Pony* (p. 19) and *1972 Complete – the Mummy* (mummified female) (p. 30).

PAGE 23: Five variations of iron scolds to control "nags" (wives).

PAGE 40: Illustration of school house discipline: extreme heels and tight waists.

Bizarre **Vol. 4** (1946)

Cover illustration of close-up of heels bound with ribbon made into a bow.

PAGE 6: John Willie illustration of a "back-board" to improve a woman's posture.

PAGE 17: John Willie's 6 panel illustration, *Waist Space*, of a woman that purchases a waist reducing machine and enjoys using it so much her waist becomes smaller and smaller until she pops in half!

PAGES 23, 28–30, 32–33: *The Magic Island No 1.* Sailor washed up on South Pacific island beach wakes up to blonde pony girls (p. 29). "Standing shoulder to shoulder ... attached by harness ... They had nothing on either except the harness and bridles and sandals ... They smiled at me as much as their bits would allow."

PAGE 25: *Fancy Dress.* John Willie's original illustrations of reader's costume suggestions were available to the one who supplied the suggestions free of charge!

PAGE 27: John Willie illustration of the *Bell Hop*. Brilliant. Provocative.

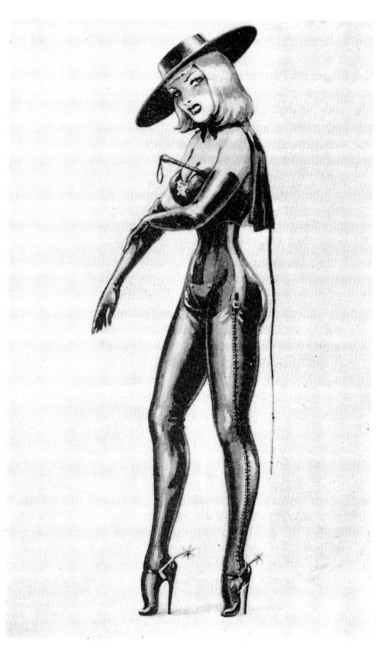

A smart leather riding costume

Bizarre **Vol. 5** (1946)
The correspondence issue.
PAGE 21: A menage of four photos of very high heels.

Bizarre **Vol. 6** (1951)
After five years Bizarre re-appears!
PAGE 14: A fabulous menage of very high heels and stockinged feet.
PAGE 17: Holly in silky black panty, bra, hat, matching dark lipstick & attitude.
PAGE 41: Miniature female figures drawn in the margin of a letter from the editor.
PAGES 34–35: Fancy Dress for special evenings – watercolors of costumed creatures.
PAGES 36–37: 4 illustrations of masculine men in frilly & unisex outfits.

Bizarre **Vol. 7** (1952)
PAGES 12–13: Action illustrations of fit females in all variety of skirts. The frustration this beauty feels when choosing between a long, short, tight or loose skirt leads to her walking away nude except for heels & hose.
PAGE 22: Unusually intense photo – "ball masque" – of person in full face bondage, leather cape, gloves and leather chastity belt with silver studs.
PAGE 38: Training corset & shoulder brace.

Bizarre **Vol. 8** (1952)
The cover is brilliant. Of course a woman in corset is a figure "8".
Inside cover: Woman in laced leather corset dress & shoulder brace.
PAGES 14–15: Fancy Dress. John Willie illustrations: the "Cracker" woman as fire-cracker!
PAGE 27: John Willie illustration, *The Bloomer Girls* – a breeze uplifts the skirts revealing the front & back of two young frolicking beauties.

Bizarre **Vol. 9** (1952)
A profile of a full-breasted orange butterfly in heels for the cover.
Inside cover: John Willie watercolor of ethereal, severely-corsetted blonde.
PAGE 4: 'Arty' photo of woman in extreme heels getting into streamlined auto.

PAGE 21: Fancy Dress – the Slug costume, armless with hood over the eyes.
PAGES 43, 58: Six snapshots of shoes made of black kid with 5" platform & 10" heels (p. 43). Photo – women in rain gear (p. 58).

Bizarre **Vol. 10** (1952)
PAGE 4: Man Ray-like photo of man's wrist trapped by woman's heel!
PAGE 8: 6 John Willie illustrations of gagged beauties, each hairstyle unique as the gag.
PAGE 24: Fancy Dress. The concept & John Willie illustrations: that man wear frilly outfits designed specifically for man's typical physical attributes.

Bizarre **Vol. 11** (1952)
The cover of John Willie pen & ink drawings encompass all the topics from earlier issues – bondage, corsetry, dominance, etc.
Inside cover: John Willie watercolor of buxom Miss Wasp-Waist, 1953.
PAGE 8: Photos & watercolors of woman in extreme heels adjusting her hose pushing her Bentley and laboring under the car in heels.
PAGES 14–15: 3 magnificent John Willie watercolors of damsels in severe figure training.
PAGES 22–23: Fancy Dress. John Willie illustration of Wooden Soldier, P.B.I with backpack to conceal her arms, & a Nelson with double eye patches & arms bound.
PAGES 34–35: Miss Bizarre. Willie's concept of the ideal woman – she must be both dominant & submissive. In the illustration one hand has a whip and the other is bound behind her. One high heel with spur & both heels chained together, one thigh with 6 garters, one with bloomer; a large nose ring & "drenched in perfume", covered in jewelry with one bracelet and a pair of handcuffs. Nice! (p. 35).

Bizarre **Vol. 12** (1953)
The cover of a giantess whipping her eleven female charges into shape. All are corseted, all wear black stockings, opera-length gloves & black bows except for one green bow. All are leggy. The

rooftop damsel smokes, another hides behind the enormous heel of the shoehouse.

PAGE 8: For the love of mackintosh & high-laced boots (photos also).

PAGE 15: *From Girl To Pony* (to be continued). Bill succeeds in transforming future wife into "high action" pony girl. John Willie watercolor of woman with harness which pulls her forehead back & chest forward with the toe of the raised foot level with the knee of the other foot.

PAGES 19, 21: *Fancy Dress & the Peacock Parade* – masculine men in frilly wear.

PAGE 23: John Willie watercolor of *The Silent Piper*, a metal arm & neck restraint.

PAGE 51: The anatomy of a 6" heel.

Back cover: John Willie watercolor of Jane Russell (?)-inspired damsel in wasp corset.

Bizarre **Vol. 13** (1954)

Comical cover of giant women in extreme heels clubbing subservient tiny men. One man under heel, another begging at her thigh. Two women lie at the bottom in rope bondage. Note the repeated corset motif.

PAGE 7: John Willie, archaeologist, digs up evidence of giantesses who wore 12" heels & a leather corset laced to 14", and who were enslaved by shorter, smarter men.

PAGES 34–35, 54: Centerfold photo of damsel washed up on shore showing nylon clad leg (pp. 34–35). Photo of woman in leather straight jacket with leather cloth across the eyes (p. 54).

Bizarre **Vol. 14** (1954)

Cover: Close-up photo of Betty Page with 3-button black leather gloves.

Inside cover photo: Black 5" platforms with 10" heels (double strap).

PAGE 19: Photo of female beauty in patterned lingerie & transparent opera gloves!

Bizarre **Vol. 15/16** (1955)

Correspondence issue.

PAGE 14: Retouched photo of perfect corset brunette in open-toed heels.

PAGE 77: Photos of high-fashion fetish model outdoors in tailored suit.

Bizarre **Vol. 17** (1956)

Cover photo of busty woman in satin dress and open-toed heels with black scarf over her face.

PAGE 10: Photos of high-laced kid boots with seamed black fishnet hose.

PAGE 15: The history of silk stockings (photos).

Bizarre **Vol. 18** (1956)

Cover: Retouched photo of thighs, black leather gloves & full body in black leotard.

PAGE 13: *Entre Acte* – John Willie illustration of vamp with whip and droopy earrings.

PAGES 26, 28–29, 46, 51, 53: Correspondence. Illustration of 5 corsetted beauties attacking the editor (p. 26). Illustration of filmy bra & panty-clad blondes attacking the editor (p. 28). Photo of tight high-laced leather boots & corset (p. 29). Illustration: Training corset with safety belt (p. 46). Photos of mermaid & man bound by net in water & to log (p. 51). John Willie illustration of a corseted blonde in heels & gloves and a "straps only" hobble skirt (p. 53).

Bizarre **Vol. 19** (1956)

Cover: Illustration of wasp-waist topless blonde in top hat & matching bull whip.

PAGES 22–23, 25: Photos of single 8" high-heel shoe & beauty in leather shorts, heels & seamed hose (pp. 22–23). Illustration of corsetted beauty on her knees (p. 25).

Bizarre **Vol. 20** (1956)

Cover: Face & upper torso encased in black leather with leather collar.

PAGES 19, 25, 37, 45, 63: Photo of pretty Vera Ellen in corset & frills (p. 19). Photo of multi-toned leather laced boots (p. 25). Photo of a woman in the shower wearing her dress with the water streaming down her body (p. 37). John Willie illustration of *Pretty Polly* (p. 45). Photo of laced masked beauty (p. 63).

Bizarre **Vol. 21** (1957)

PAGES 22–26: A dissertation on the ibitoe – the body modification & ritual a young itaburi of tight waist band that is worn for life. Nose & ear piercings. Western male writer decides to become ibitoe & uses old-fashioned leather ladies belt. The itaburi edges "feel like two hot wires, one around your pouting chest, the other around your hips." He cinches it to 16" (photos of man wearing itaburi).

Bizarre **Vol. 22** (1957)

Cover of lower half of a woman with wrists & ankles bound with ribbon.

Back cover: Photo of front cover model.

PAGES 15, 23, 27, 47, 32–33: A wide-brim hat & whip in thigh-high laced boots & bare midriff (p. 15). Photo of legs in heels & nylons bound at the ankle (p. 23). *"Do it youself" Department:* Description & diagram of converting standard high heels into 6" spikes (p. 27). Transvestism guide to feminity (p. 47). A collage of leg & heel photos (pp. 32–33).

Bizarre **Vol. 23** (1958)

Cover drawing of high-heel, high-hat, high-booted lion tamer with whip.

Inside cover: Photo of smiling Marilyn Monroe in corset.

Back cover: Nude profile of Lilly Christine, the "Queen of Cabarets", sitting on white fur.

PAGES 9, 12–13: Drawings by Mahlon Blaine of a dominatrix riding an old man in boxers & one of a strange creature binding a nude woman.

PAGE 19: Photo of Brigitte Bardot as fetish doll in corset and open-toe heels.

PAGES 22–23: Photos of Jayne Mansfield and other beauties in short skirts.

Bizarre **Vol. 24** (1958)

Cover art by Mahlon Blaine of corseted faceless female smoking a cigarette seated on a stool with laced boots, nylons & gloves.

Bizarre **Vol. 25** (1958)

Cover illustration by Mahlon Blaine of corset frilly panties, garters & stockings.

Inside cover: Mahlon Blaine illustration: Woman as hour-glass in gloves & stockings.

PAGES 25, 32: Photo of bikini-clad Betty Page on a couch (p. 25). Photos – advertisement of women in girdles & hose (p. 32).

Bizarre **Vol. 26** (1959)

Cover by Mahlon Blaine of a woman with extremely long finger nails in a diamond-studded catsuit & heels sitting on the head of a smiling devil.

PAGES 32–33: Photos of woman in rubber suit & full face mask.

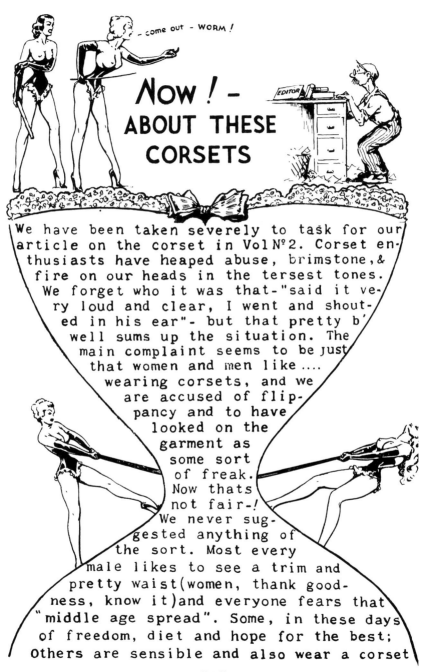

– come out – WORM!

NOW! –
ABOUT THESE
CORSETS

EDITOR

We have been taken severely to task for our article on the corset in Vol N° 2. Corset enthusiasts have heaped abuse, brimstone,& fire on our heads in the tersest tones. We forget who it was that-"said it very loud and clear, I went and shouted in his ear"- but that pretty b' well sums up the situation. The main complaint seems to be just that women and men like.... wearing corsets, and we are accused of flippancy and to have looked on the garment as some sort of freak. Now thats not fair-! We never suggested anything of the sort. Most every male likes to see a trim and pretty waist(women, thank goodness, know it)and everyone fears that "middle age spread". Some, in these days of freedom, diet and hope for the best; Others are sensible and also wear a corset

[5]

BiZARRE

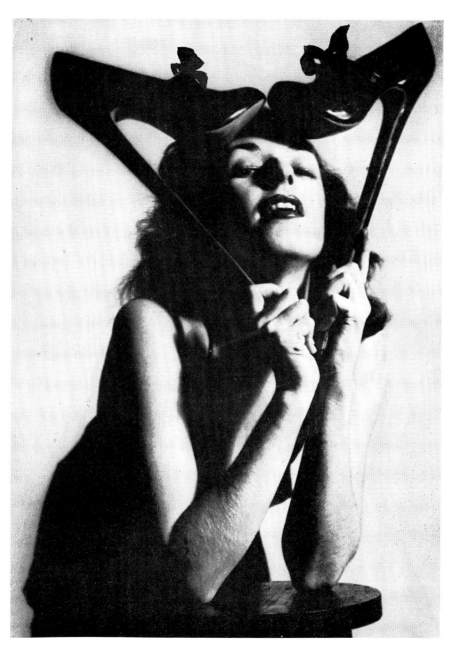

ACHILLES — for heels of any height

LADIES !!- PLEASE !

You've taken our jobs !

Our beer and tobacco !

Our clothes ! yes - our hats · our ties -

our games !

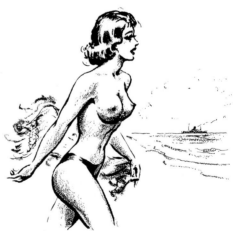

Even our trousers !

Please ! Why not take our SWIM SUITS ?

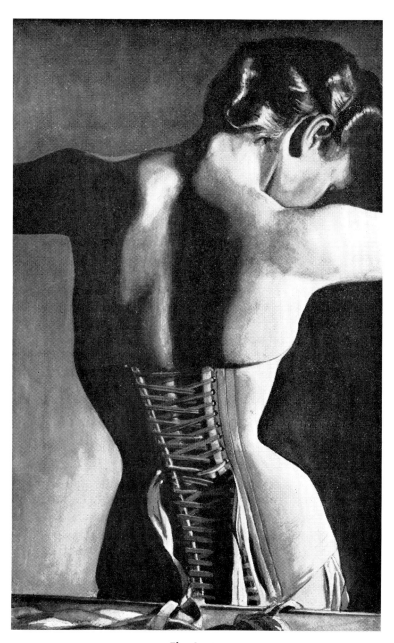

The Laces

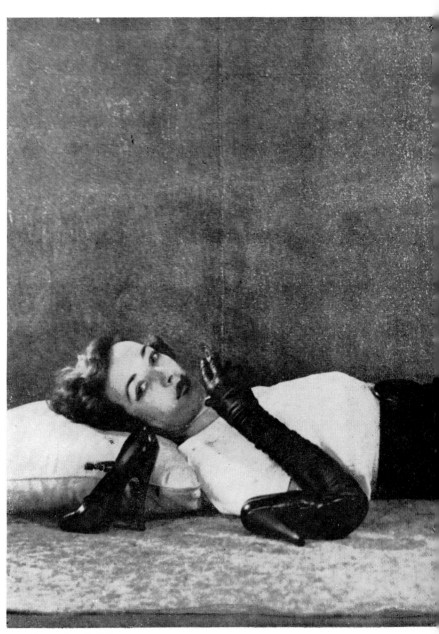

Boots by Achilles

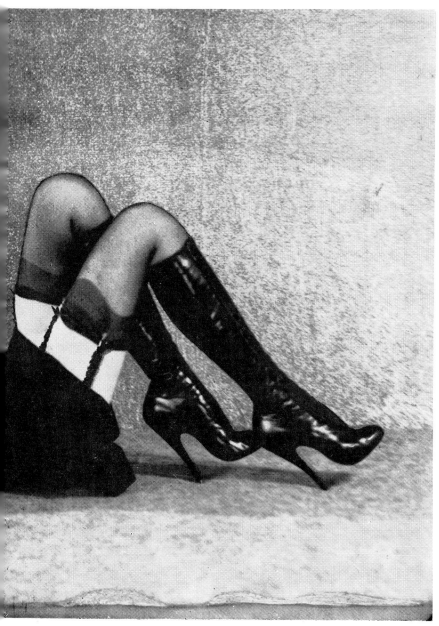

The Model Rests

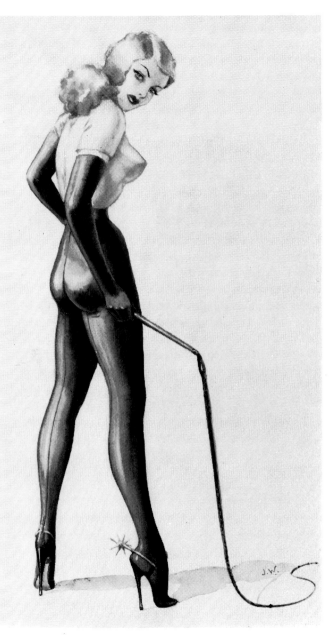

The Riding Mistress

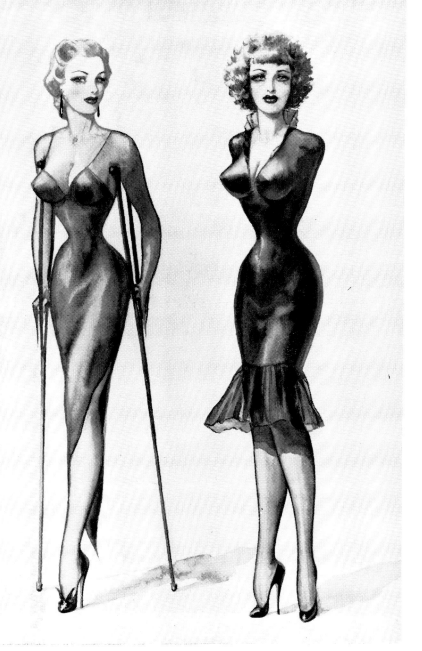

If you are handicapped —
you can still make the best of what you've got

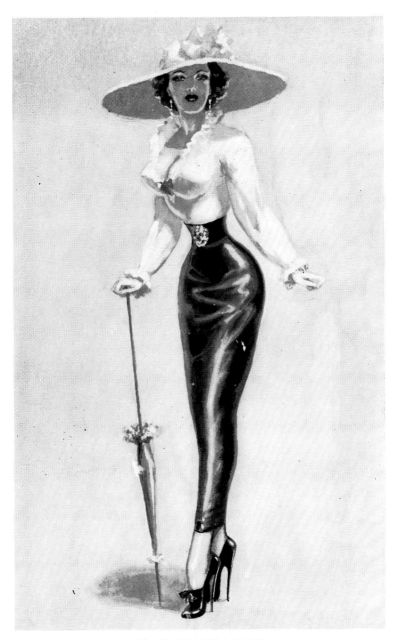

The Hobble Skirt (1910)

BIZARRE

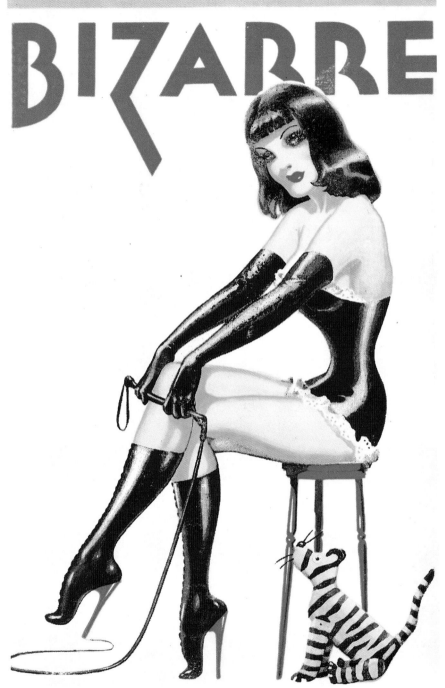

you simply MUST make it meet!

with the added charm of the short very tight skirt

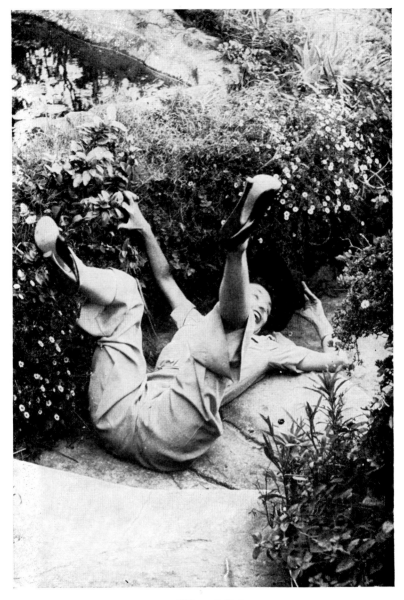

— Missed it !

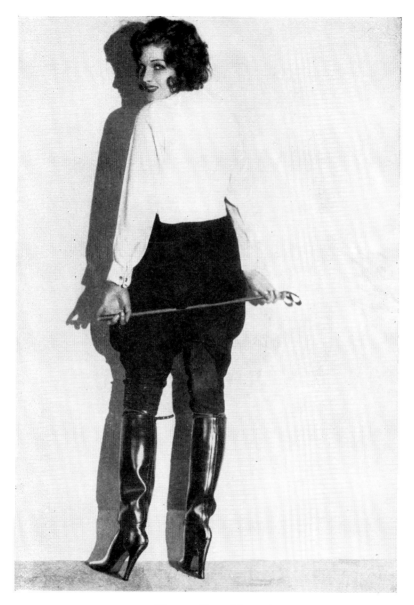

smart? — well we'd say so

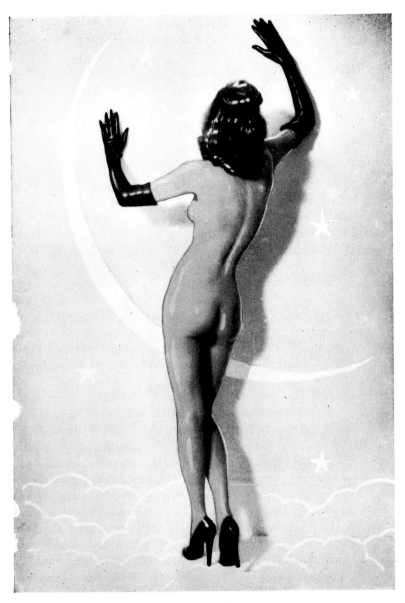

reaching for the stars

for slaves of fashion

Achilles

theatrical footwear

VOL 3 1946

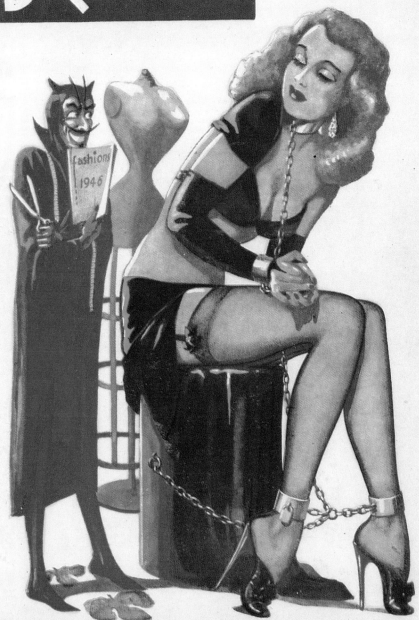

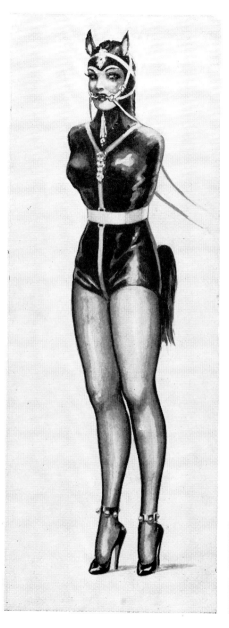

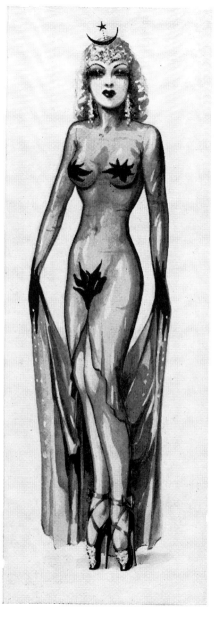

"The Pony" *"Night"*

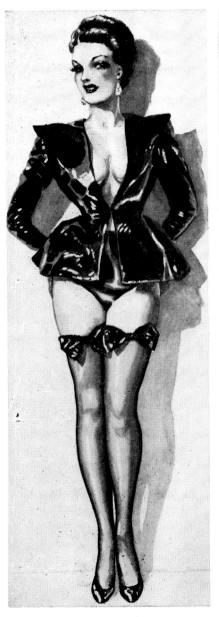

Rain *The Peasant*

[20]

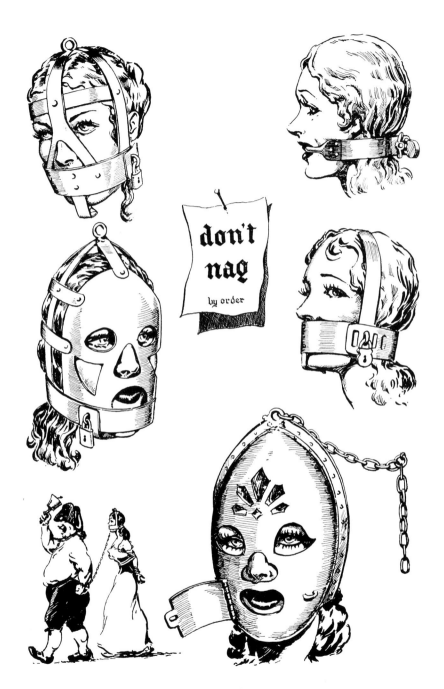

don't
nag

by order

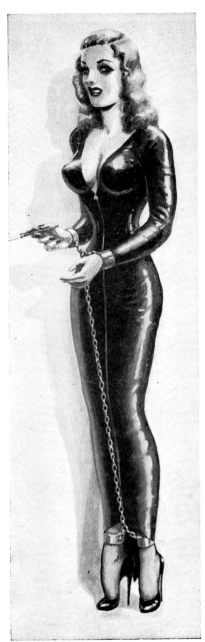

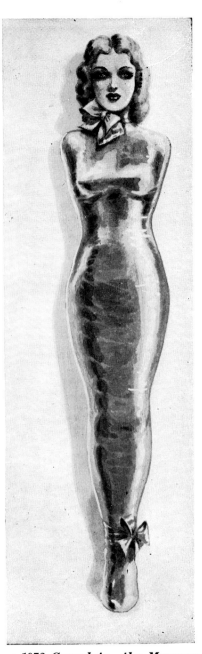

A bit more, 1952 *1972 Complete—the Mummy*

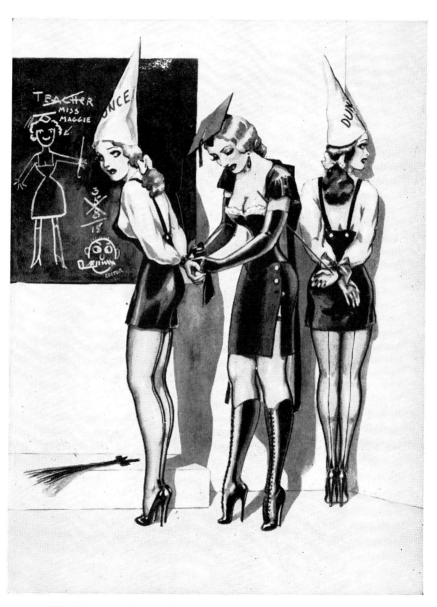

That's enough of this nonsense — Now you'll behave

VOL 1 No. 4 1946

BIZARRE

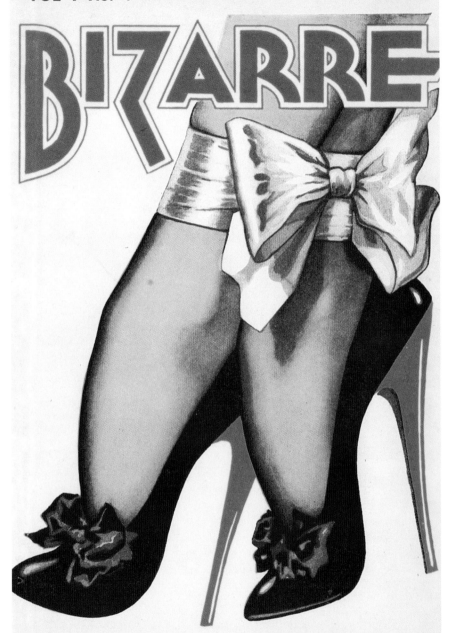

THIRTY-FIVE CENTS

The back-board

This shows the material from which J.W. has made all the illustrations for this article —giving modern glamor with exactness of detail.

WAIST SPACE

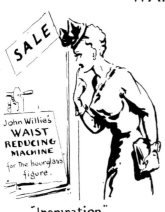

"Inspiration"

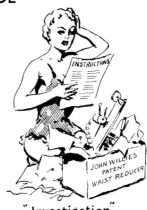

"Investigation"

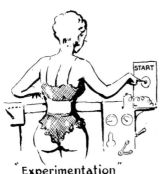

"Experimentation"

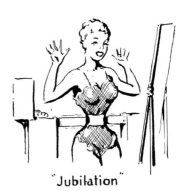

"Jubilation"

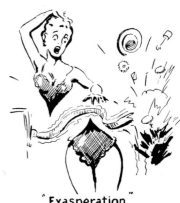

"Realization"

"Exasperation"

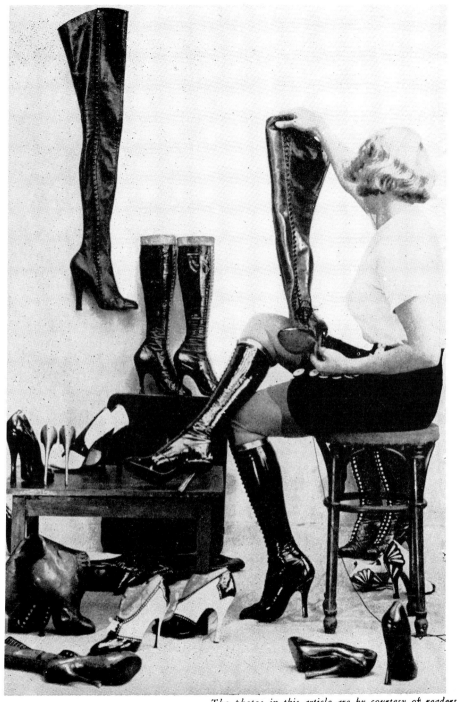

The photos in this article are by courtesy of readers

THE MAGIC ISLAND

A tale from a bottle
No. 1

Dear Mr. Editor:

It occurred to me that the enclosed letters might be of interest to your readers. They were found in sealed bottles washed ashore on the coast of Chile and are from a nephew of mine—a good-looking young devil of 23 with more than his fair share of luck.

Yours,

J. McPherson.

LETTER No. 1

Will the finder of this bottle please forward the enclosed letter to Mr. Jim McPherson, Chief Engineer, c/o G.P.O. London.

Dear Uncle Jim:

I have no means of telling whether you get this letter. I'm simply trusting luck to the sea. In any case there is no chance of your answering because I don't know where I am except that it's on an island—accessible only from one tiny beach.

As the Admiralty cannot know exactly what happened you'd better tell them that I believe we were torpedoed by a sub on the 15th December, and that I am the sole survivor. I was walking on deck when it happened—and the ship just blew up and by a miracle I found myself in the drink still all in one piece. I managed to find some wreckage to cling to and then it started to blow —and for two days and nights I was like a damned sub myself most of the time—but somehow I managed to keep topside until one night when I was just about ready to cash in I landed with a bang and a bump on good old dry land. I crawled up above the tide level and passed out completely.

I'll have to tell you the story as it happened to me, otherwise you'll think I'm the most awful liar for this is the most fantastic spot you could ever dream of—a real Utopia protected from the march of civilization as we know it by great unscaleable rock cliffs. An absolute paradise inhabited by the most charming folk it has been my good fortune to meet. But to continue with my story.

I was aroused from my collapse on the beach by someone shaking me and found myself surrounded

(continued on Page 28)

[23]

FANCY DRESS
for special evenings

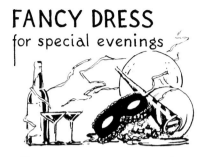

THE ILLUSTRATED suggestions for fancy dress in No. 3 have proved so exceedingly popular that we are making this a "must" in all future issues.

"Miss Texas 1945" had a terrific host of admirers, and again we shall be glad to hear what you think of the ones illustrated in this issue, and to receive your own ideas on what makes the "perfect party fancy dress" or costume for "special evenings."

We take this opportunity of thanking all those many readers who sent in "ideas" which are not illustrated. You will all realize that we're very lucky to have enough paper to print this issue at all (sorry to keep rubbing it in)—

Funnily enough our forecast on the hobble skirt for 1952, which with 1972 could make an excellent fancy dress, is not new. We have discovered that smart Parisiennes in the '20s, when the "sheikh" was the vogue, took to wearing chain ornaments—some of them perfectly genuine steel fetters, as restricting as those worn by Miss 1952 in the previous issue.

One reader has sent in a delightful suggestion which will definitely come soon—a mermaid costume. A "zipper" arrangement opens the "tail", enabling the wearer to dance, but when seated this is closed, giving the full mermaid effect.

And now to describe the costumes suggested by our readers in this issue. (We again remind you that if you want the original J. W. sketch illustrating your letter, all you have to do is to write in for it.)

The arab costume incidentally is J. W.'s own suggestion, and his stock stand by if he gets caught unprepared. He makes it out of two sheets and a towel—one sheet goes round the waist like a sarong —the other is draped over the head and trimmed so to speak by the towel which is wound as a turban. Burnt cork applied skillfully makes eyebrows and whiskers.

The "bell hop" and the "convict" we're afraid would not be possible at the moment because the specifications call for silk tights which are still unobtainable. Whether you could ever buy striped tights we don't know—but anyway if you couldn't spend the time painting black stripes on white silk, you could always just wear it plain.

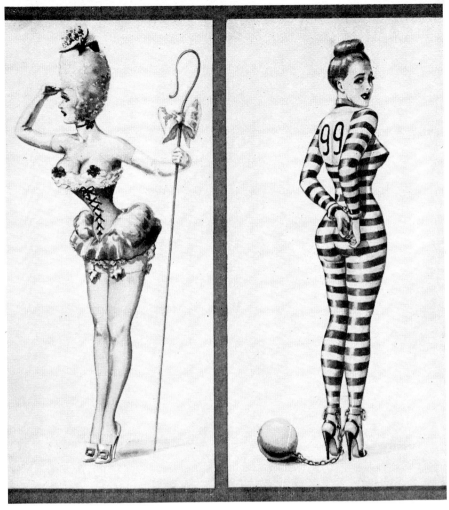

DRESDEN SHEPHERDESS. Much frothy white lace — white kid gloves set off by black corsette. Satin pumps with silver buckles and stockings to match — High, curled, white wig.

CONVICT. Black and white striped tights — handcuffs — leg irons and ball and chain (Ball can be cistern float).

ARAB. A simple costume to make — effective either in white or in coloured drapes. Chain ornaments, wristlets, anklets can be added.

BELL-HOP. Neck to toe skin tight tights. Stiffened collar — square padded shoulders. Jacket indicated by piping at waist and cuffs and buttons.

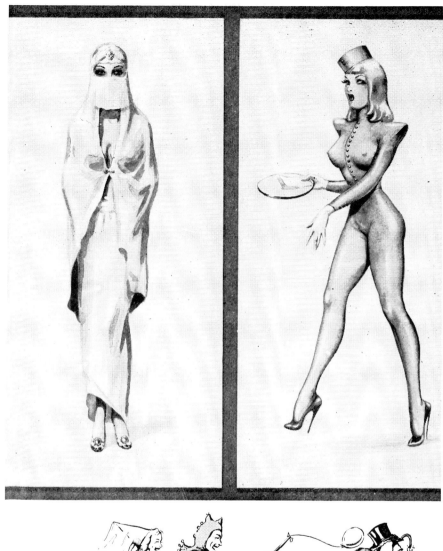

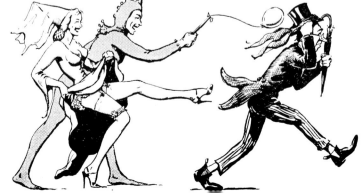

(Continued from Page 23)
by some natives armed with spears and the first thing I noticed about them was their fine physique and the character in their faces. They were more like bronzed Greek gods than natives.

They pressed a wet sponge to my lips and kept refilling it until my throat stopped burning like a lime kiln and I could talk. I asked them if they spoke English and after that my troubles ceased for they talk the same lingo perfectly without any accent.

They produced a gourd of excellent wine and some tasty little things to eat and when I was more or less able to sit up and take notice, plunked me on a litter and began to carry me over the rocks toward the towering cliff face.

My bearers moved smoothly and swiftly over the uneven going to the entrance of a small cave—here a halt was called while torches were lit and then in we went, deeper and deeper into the cliff. The cave seemed to get bigger and bigger and then we began climbing up one side. There was no regular path, just easy footholds here and there — then the roof seemed to come closer and we were in a natural tunnel—still climbing. We went on and on for heaven knows how long and then at last I saw the tint of daylight on the rocks ahead and rounding a corner we came at last out once more into the sunlight—and the most beautiful surroundings.

It is quite impossible for me to do justice to it, the whole darned island is the same — just a mass of tropical green — flowers everywhere all the year round — birds singing and a perfume which changes all the time as each different flower seems to take its turn in pumping buckets of scent into the air.

To crown it all there are no pests of any kind (human or otherwise), no snakes, no poisonous spiders or centipedes—and no mosquitoes. No heap of stupid rules and regulations — no liquor laws, and no morality laws except the very simple practice of good manners, tolerance, and consideration for the other fellow's point of view. As a result vice and crime are unknown. Everyone has enough work to keep life from getting boring. No strikes, no lockouts — no landlords — each man owns as much land as he can use for whatever purpose he requires — he cannot own more of anything than he can use. There are no witch doctors, ancient or modern. They say quite simply that the truth is no one knows what happens when we die—and so anyone who says he does is obviously a liar. All that is required of you as a citizen is that you do your part in making

life on this island as pleasant and happy as possible for everyone else so long as you live. What a place! But to continue—

We pushed our way through the undergrowth and there in a clearing was the most beautiful girl I'd ever seen coming toward me, her hands outstretched in welcome. (Yes I know you think I'm a most awful liar—but I can't help that —this is, as I've said, the most fantastic spot you've ever heard of—and it's all the truth.) I decided I wasn't dreaming but it was pretty staggering. Her hair was like a black satin cloak rippling to her waist in the soft breeze and her figure was absolutely stunning. I had plenty of opportunity to judge this and to notice that her skin was like silk, with a most beautiful even tan, for she wore nothing at all except an abbreviated sort of skirt of silk with a gay pattern in red flowers on it, and a pair of sandals with amazing heels (oh, I forgot the flower—she had a flower in her hair).

Like my bearers there was nothing of the native about her except in the grace of her movements — she looked more like a bathing beauty at a fashionable beach resort. She was just b ... lovely at any time, anywhere, not just to a tired, and miserable sailorman washed up on the beach of a South Pacific island.

In perfect English (and her voice was like a caress itself—another of the wonders of all these wonderful people) she asked me how I felt, helped me off my stretcher to which I had been glued in astonishment—and then my eyes really did pop out of my head, for behind her in the shade of the trees to which she was leading me were three gorgeous blondes standing shoulder to shoulder in line abreast in front of a little rickshaw to which I saw they were attached by harness like ordinary pones. They had nothing on either except the harness and bridles and sandals, a tassel of coloured beads fore and aft so to speak, and a large plume attached to the brow band of the bridle.

Their hands were not much in evidence and as I mounted into this Island Rolls Royce I noticed that each girl's arms were folded behind her back and secured in this position with straps—but there was nothing of the captive slave in their behaviour—far from it — they smiled at me (as much as their bits would allow) — their great soft dark eyes twinkling under impossibly long curved lashes, and as my hostess arranged a cushion for me stamped their little sandalled feet and shook their heads in impatience.

Once settled comfortably, my

companion gathered up the reins, clicked her tongue, cracked her whip, flicked the shoulders of her unusual steeds and off we went. I turned to wave thanks to the friends who had carried me up the cliff and then fixed my attention once more on the intriguing spectacle in front of me.

The ponies needed no urging — they ran, in perfect step, with a smooth effortless grace that was a pleasure to watch—and did they go fast! with never a pause for breath. I have since found that any girl or boy here can do the 100 in 7½ sec. and keep up that speed for a mile.

I was naturally full of questions but though feeling much better was still too worn out to talk. My companion sensed it for after asking how long I'd been in the water said, "You must be very tired, just rest and we'll have you home in no time"—and instead of talking she sang softly in time to the runners as they flashed down the well worn winding track.

This, with the wine I had drunk (I still clutched the gourd—trust me for that), the scent of the flowers, and the sun as it flickered through the leaves, playing hide and seek on the satin skins of our ponies, and twinkling on the highly polished leather of the harness— made me drowsy, I was hypnotized by the rippling muscles of the gorgeous limbs in front of me, the little flying sandaled feet that hardly seemed to touch the ground, and the slender fingers now stretched, and now clenched to relieve the tension of the straps.

The gay red plumes of their unique headdress bobbed and waved in the air, challenging the brilliant colours of the birds which flashed overhead and the vivid butterflies which fluttered around the place.

One particularly large one of a most beautiful deep blood red and purple hovered around the heads of our ponies and then alighted on the shoulder of the one on the portside. This caused considerable excitement in the team—they suddenly ran even faster.

"That's lucky," said my companion, "for Gail, but not for me for it means I'll lose the finest team on the island. I know what you're thinking," she went on — "you're wondering about the ponies — every newcomer does — oh no, you're not the first shipwrecked mariner to land up on the beach," and her eyes twinkled.

"You see, we've got no horses, never have had—and it's been the custom for years for all the young girls from the age of 16 to 20 to take their place—I'll tell you all about it later."

"How do they like it?" I asked.

"They love it!" she replied. "It

is each girl's ambition to be in the fastest team. Why, that's what all the excitement is about at the moment. You see, Gail is over age for a pony but she asked the people's permission to stay on being in my team until after the annual races because of the other two and we're certain to win—but that particular butterfly settling on her shoulder means that she'll marry before the moon wanes—and then she'll simply have to go." By this time the ponies had got quite out of hand in their excitement — and were jumping and throwing their heads in the air while the rickshaw swayed drunkenly.

With whip and rein my companion collected the team until they were travelling smoothly again—but the butterfly still rested on Gail's shoulder. In silence we watched it, and then out of the corner of my eye I saw another, even bigger, butterfly of the same kind. I couldn't help grinning as the damn thing fluttered around my face and then rested on my shoulder. I looked over at the girl beside me and to my surprise saw consternation on her face, but suddenly another butterfly came out of nowhere and rested alongside the flower in her hair—and her expression changed to one of expectancy. Then her eyes sparkled and she laughed happily as those

two butterflies started chasing each other between us—now they were both on her, now on me.

The omen, after what she had just said, was too obvious.

The team sensed something was going on and Gail turned her head —immediately she drew the attention of the others to it and then they went plumb crazy. They threw their heads in the air. Their harness creaked as they strained against it—and if we'd gone fast before we literally flew now.

We shot round corners on one wheel, and even the butterflies decided to stop playing tig and to hang on for dear life. Gail's still clung to her shoulder, and I could feel mine somewhere up in my hair while the other had sought refuge on one of the beautiful breasts of the girl at my side.

She had given the team their heads and resting back on her cushions was singing again — a happy lilting tune, red lips parted, dreamy eyes half closed. Still we flew along.

The track widened and we occasionally passed a pretty little thatched hut tucked away amongst the trees—and little orchards and patches of cultivated land.

We passed other teams of ponies coming and going — sometimes a pair of girls in the shafts and sometimes three as in ours — and

I noticed with delight that all were equally as pretty.

My lovely companion came out of her reverie now and brought the team down to their long swinging stride again but they were most unwilling to obey and it was only after severe use of whip and reins that she managed to control them — in fact it really wasn't until the butterflies flew away that she gained the mastery but we were still going extremely fast and it was wonderful to watch her handling as we weaved through the traffic which was becoming more congested (and no darn traffic cops or red lights).

At last we came to the main village, but that hardly describes it; a fairyland is a better word — little huts almost hidden in an absolute profusion of flowers. Men and women waved in friendly greeting as, without checking pace, we flashed through a maze of wide paths until swinging across a little bridge over a little tinkling brook we drew up suddenly before a large shady verandah, and I clambered down.

I don't suppose it's usual — in fact I'm certain no rider in a stage coach, or buggy for that matter, ever did it before — but I couldn't help going over to the ponies and saying "thank you" — at which

their eyes sparkled and they nodded their appreciation as they stood there on tiptoe—which made their harness jingle and the plumes dance gaily anew atop of their heads. They couldn't answer me because the wooden bits in their mouths, though thin and light so that they caused no discomfort, nevertheless made coherent speech impossible.

The chief with his wife and the rest of their family—for it was Malua, his eldest daughter, who had driven me in—welcomed me and helped me inside. As a matter of fact I'd finished the gourd of wine and was a bit tight but they took it to be plain fatigue. They were charming people and never have I met such gracious hospitality.

Before I quite realized what had happened I found myself bathed, and fed, resting on a couch in the shelter of a cool room—a delightful contrast to the harsh voice of the sea which I had heard at such close quarters for the last few days —and which now, as I relaxed completely, returned drumming in my ears. And I fell asleep to dream of mermaids harnessed to my raft drawing me across warm sunny seas in a glorious surfriding game of follow-my-leader.

(To be continued)

[33]

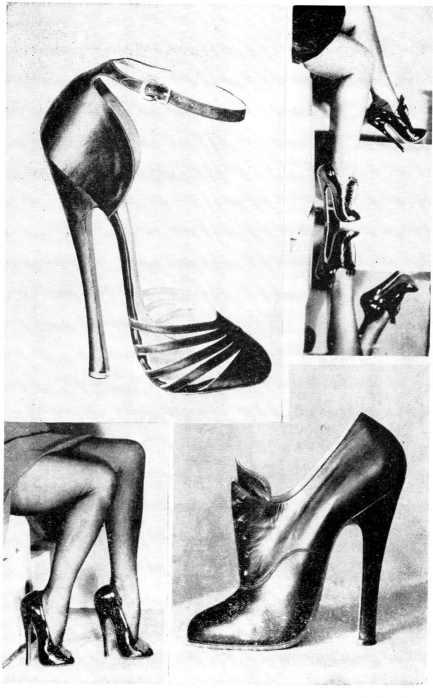

from a reader in New York

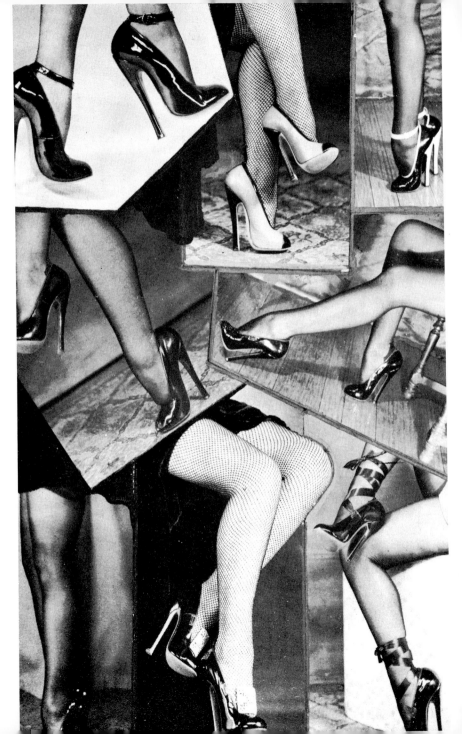

how do you like my hat?

We hope you read our Editorials. We have discovered that many people don't - which is all very trying and difficult. There is so much of consequence in them (they are usually to be found on page 4 or 5): and while we're at it may we point out that an Editorial is an article "written or sanctioned by an Editor". This therefore that you are now reading is an "Editorial".

We apologise for having to do this but we discovered that some self appointed authorities on English literature are ignorant as to the meaning of simple words. At times this can be embarrassing.

The "Letters to the Editor" in the Correspondence columns are not Editorials because the Editor didn't write them. They are written by the readers themselves, and we publish them word for word, spelling mistake for spelling mistake and if a photo or sketch is sent in which is clear enough for reproduction we publish that too.

Incidently the comments are not made by a man named "Ed". "Ed" is an abbreviation of Editor. Believe it or not but we have often been asked who Ed is!

We do not follow the practice of some publications whose "Letters to the Editor" are actually written by members of the staff. That is a dull occupation for dreary people. If you thought that we did we thank you for the compliment to our fertile imagination, but beg to point out your error. We also respect the confidence of our readers and do NOT give introductions.

We regard it as the right of every individual to express his or her views and to see them reproduced in print - even though we may not agree with them. May we therefore remind you that someone once said " Take up thy pen + write four-score", and that a good motto is "Do it now".

Editor.

FANCY DRESS
for special evenings

WE RECENTLY READ a most interesting article on the leading designers of fashion in Paris. It pointed out, among other things, that some of the creations were quite useless for the American market because no machine could hope to make them. They required the skill of the little midinette and her needle. To us this was a warning note!

In the competitive rush of modern business under private enterprise you must sell at a keen price. To do this you standardize and mass produce by machines. The "custom maker" is going out fast!

Now on the other side of the iron curtain there is--so we are told—standardized massed production by the machines of a state-controlled garment industry.

It is an alarming thought for us ordinary people that either way it goes, in this titanic battle for supremacy between the two systems, we will be crushed and trampled into a shapeless mass of automatons. On either side of that iron curtain individuality must go

by the board. Designers will be forced (by different circumstances) to simplify simplicity and standardize until only one survives—with one design! This we must buy or go naked (and it's so dreadfully cold in winter).

However, on thinking it over we can see one very bright spot in this dim outlook.

Eventually by a process of time saving elimination only lengths of cloth will be made—to be worn as a "lap lap" or "sarong"—the one final design to be worn by all concerned. Again competition (or order) will force this to be of minimum length and width so that for it to be worn a la Hollywood Lamour will be impossible. The fair sex will be able to cover up here — OR — down there so to speak but NOT both places at once.

Forced to make the choice (a real Sir d'Arcy trick) the damsel presumably will wear the thing as it was originally intended to be worn — around the hips (three cheers)—or did we hear a voice say "compromise! pull it tightly round the waist alone—like a corset."

Maybe we shouldn't worry—it's looking pretty far ahead and by that time who knows—we may have developed into a super race of headless morons which from the current trend appears far more likely than the "all-head-no-body"

ON WITH THE MOTLEY!

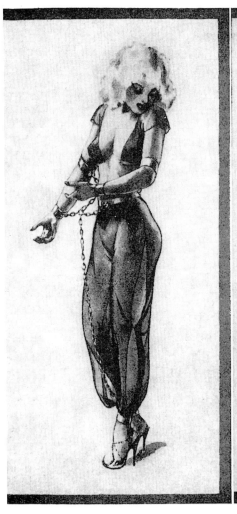

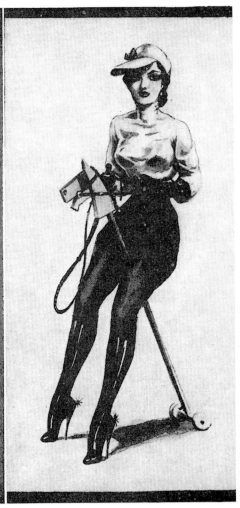

Harem Slave

Jockey

mental wizards forecast by some scientists. In the meantime let us enjoy our freedom with the fanciest of fancy dress.

Most of these costumes speak for themselves — except perhaps Ophelia—she, if memory serves, went slightly ga-ga and floated

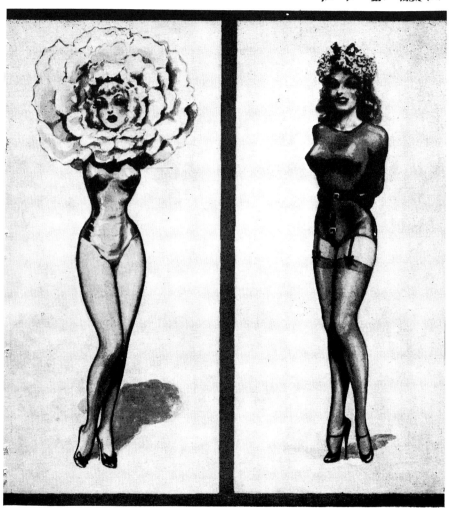

Flower

downstream with flowers in her
hair. A long armed pullover with
suitable straps attached can be
turned into a simple straightjacket.

Ophelia

The "flower's" arms are con-
spicuous by their absence some-
where up inside the petals, so she
would probably need some assis-

fine feather forecast

Business Executive	**Gentleman of Leisure**
tance at the supper table.	a century or so ago—particularly
The suggestions for the male of the species also sent in by a reader would not have been "outlandish"	the business executive. The "week-end" — with lower heels and a closer hair cut can be

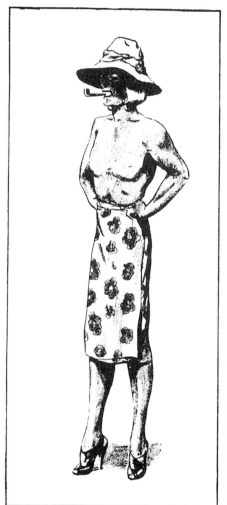

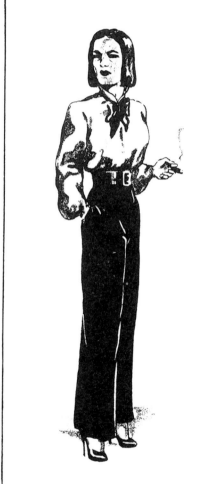

Week End	Informal Evening

seen anywhere "East of Suez".
Anyone who has wandered out to
these parts can testify that for
comfort in hot weather you cannot

beat a sarong.

The shorter version is the kil
Ask any Scotsman what he thinl
about it.

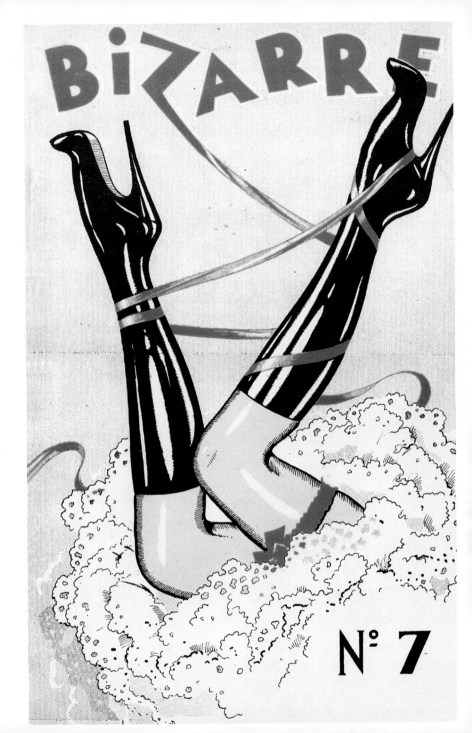

Kollar N. Y. C.

The net result

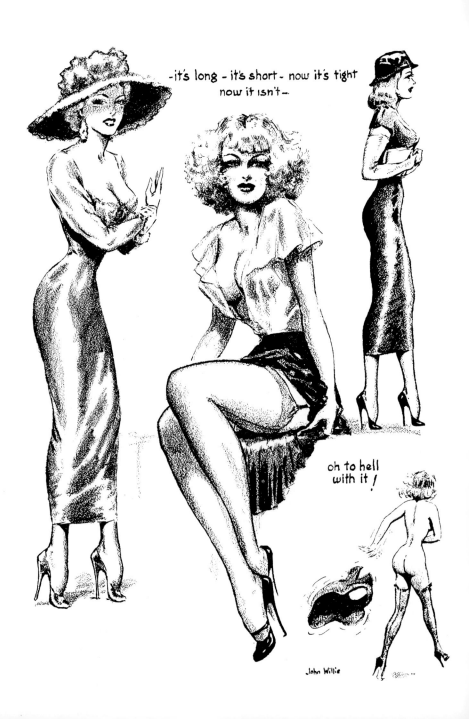

that Skirt

it's long—

it's short

—it's short
it's tight

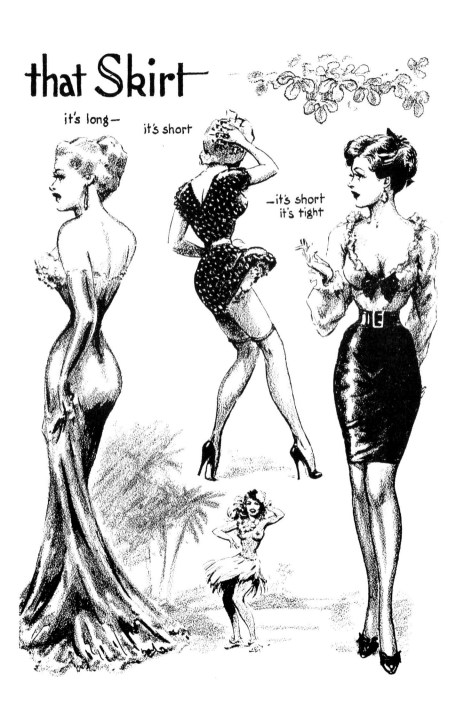

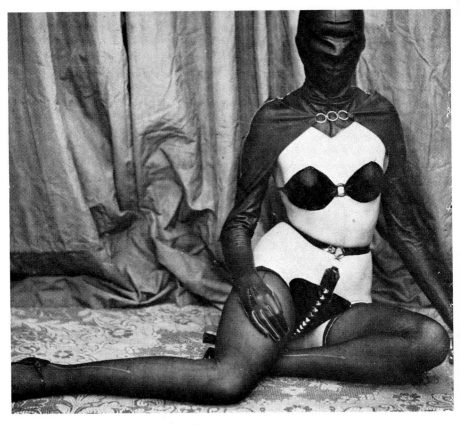

bal masque

training corset and shoulder brace

BiZARRE

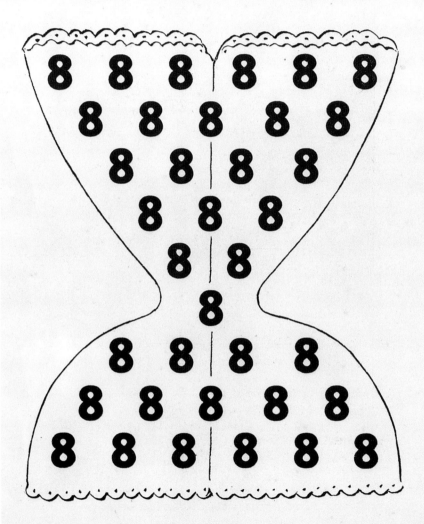

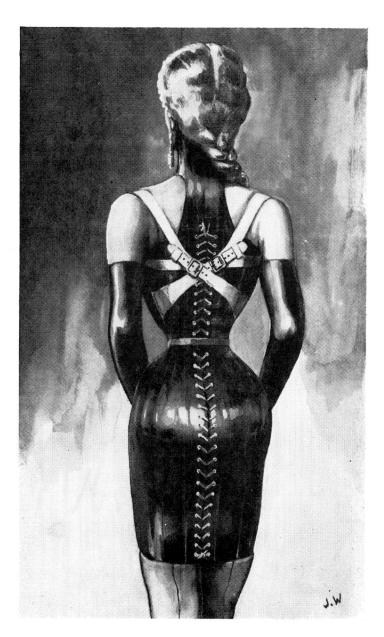

training corset with shoulder brace

FANCY DRESS
for special evenings

Overleaf are some more suggestions for party or special evening costumes. The French Maid and the Mistress are simple and straightforward enough for anyone handy with a needle.

Diana should obviously be clothed all in leather—skin tight glacé kid for preference—but the ordinary theatrical one-piece costume would do. In 1962 she will of course carry a man size butterfly net instead of a bow and arrow; and some cords to secure her captive, once she has netted him.

The cracker should be made of starched calico. Whether or not the usual motto on a piece of paper should be enclosed with a gift inside is a matter of choice. The only snag is that it's another of those costumes which make it necessary for someone to feed her with the good wine and food of the festive season. Oh yes, she can dance—with small steps. Blind Girl Fluff enthusiasts will of course insist that the top should come higher than the top of the head. She can then only see the ceiling—or nothing.

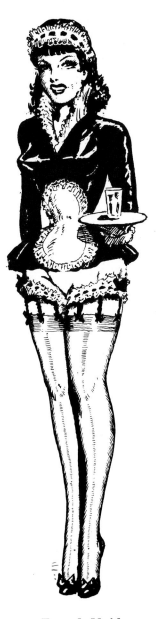

French Maid

14

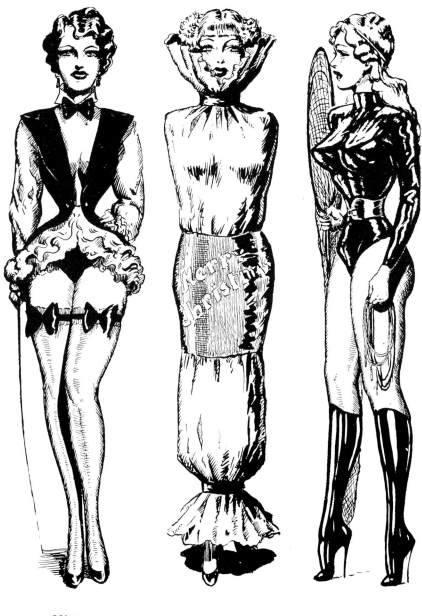

Mistress *Cracker* *Diana*

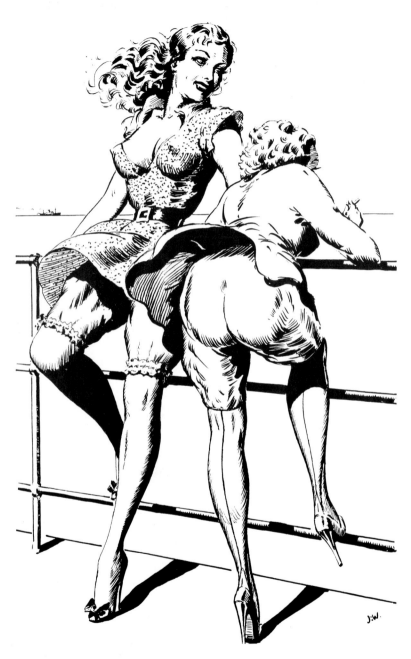

the bloomer girls

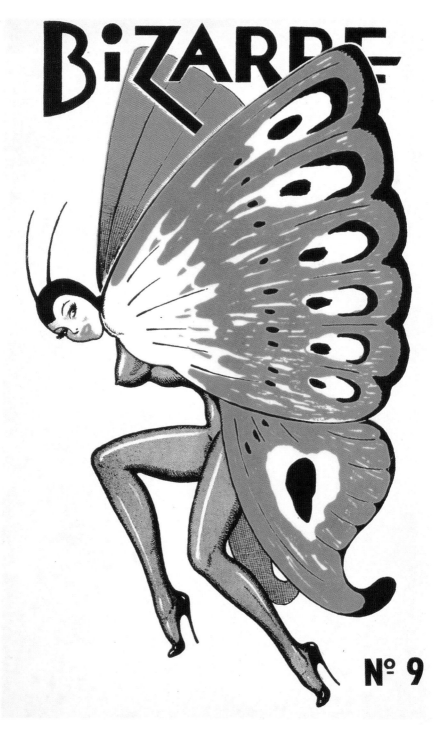

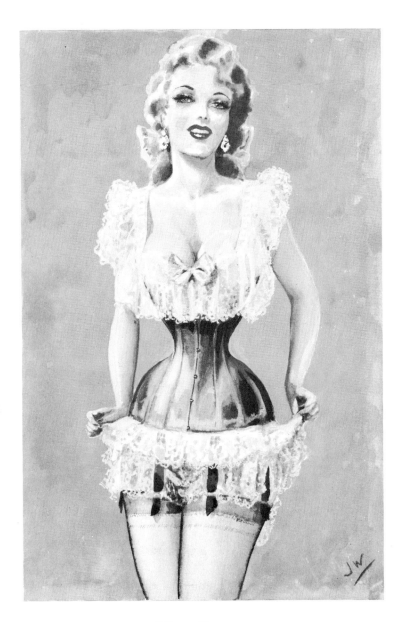

"Susan"

wonder what's inside?

FANCY DRESS
for special evenings

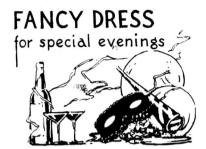

Now that the festive season is approaching greater interest centres on "fancy dress."

Zenana presents a happy idea— "The Slug"—in which the lady will obviously require much attention, and thereby attract attention, to her great delight.

However, overleaf we have offered some ideas which, though suitable for masquerade, are originally designed for Drum Majorettes.

The wearer of the all leather affair, complete with thigh boots, would not be able to do much of the usual high kicking, turning cartwheels and generally behaving like a mosquito worm in a tank, but she could certainly achieve a most magnificent, dignified and imperious strut.

Actually to our way of thinking march music does not lend itself to prancing players and pirouetting drum majorettes. The Drum Major in is charge and should show it by "her" manner.

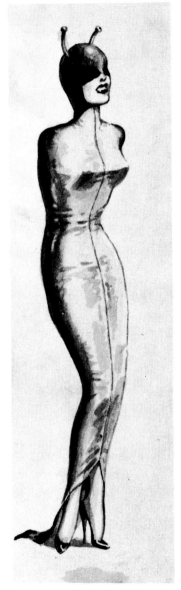

Zenana

The Slug

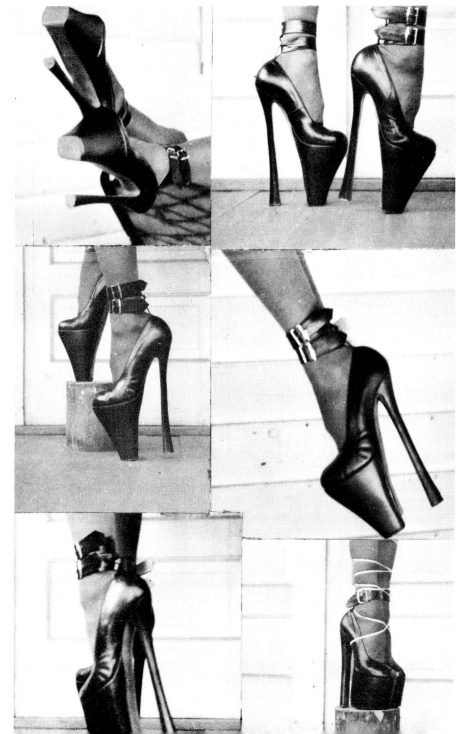

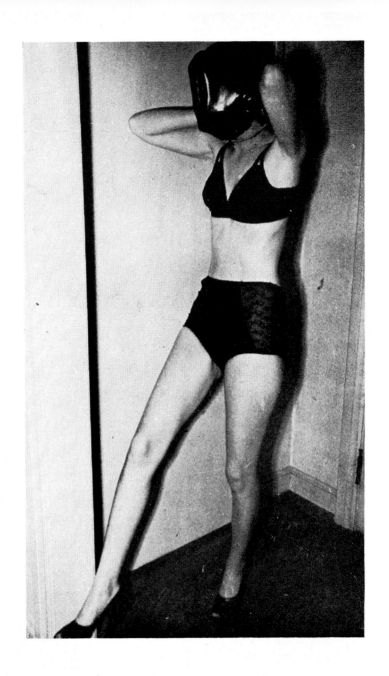

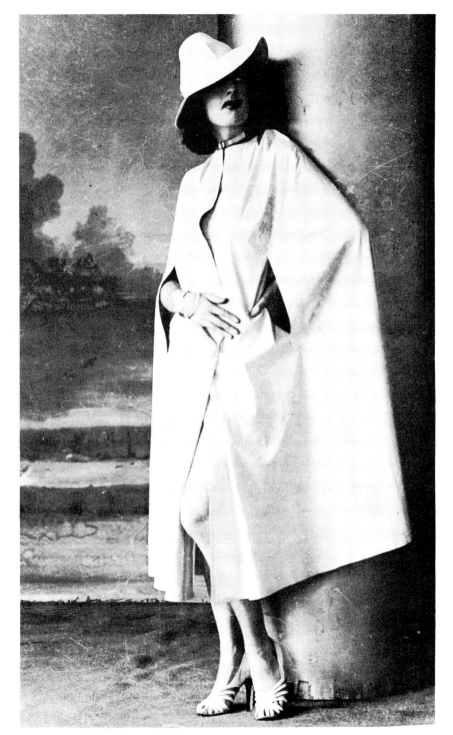

BiZARRE

J.W.

N° 10

ENOUGH OF THIS!

"Burlington"

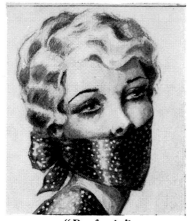

"Perfecto"

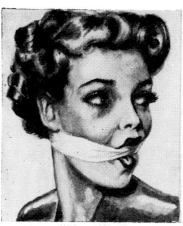

"Nautilus"

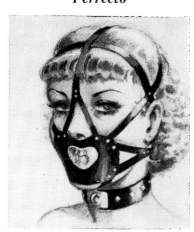

'Chien"

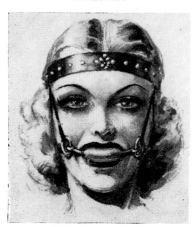

"Roehampton"

"Beanie"

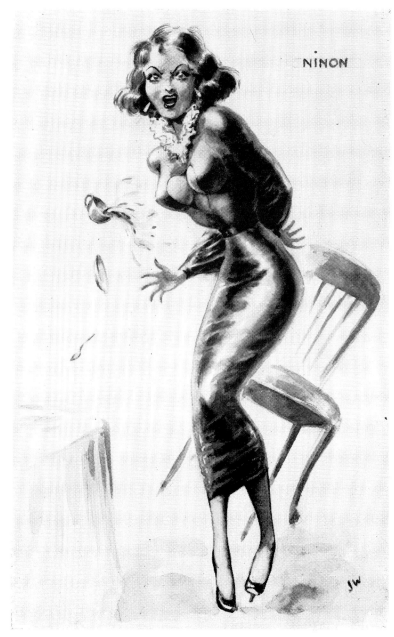

7:30 a.m. — "You and your 3-minute eggs!!!"

15

fine feather forecas

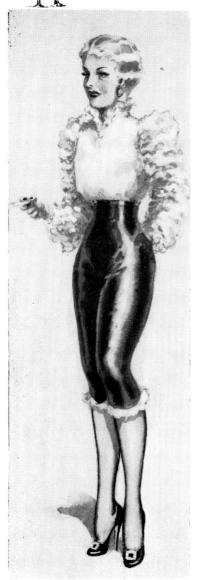

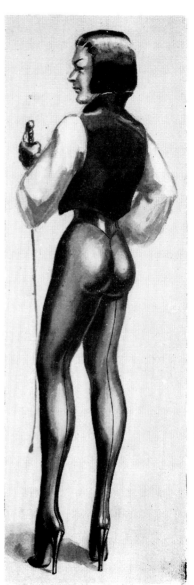

BIZARRE

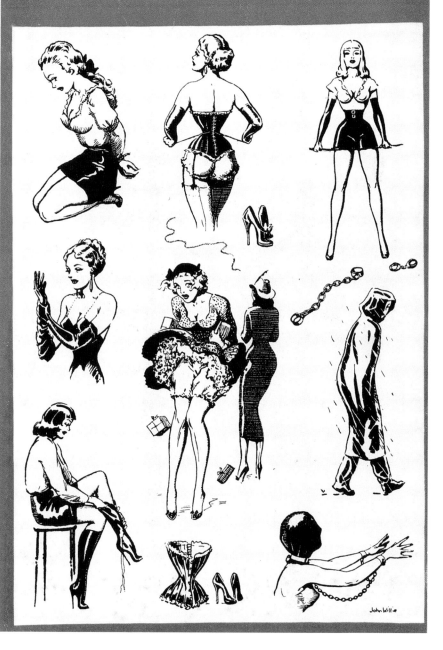

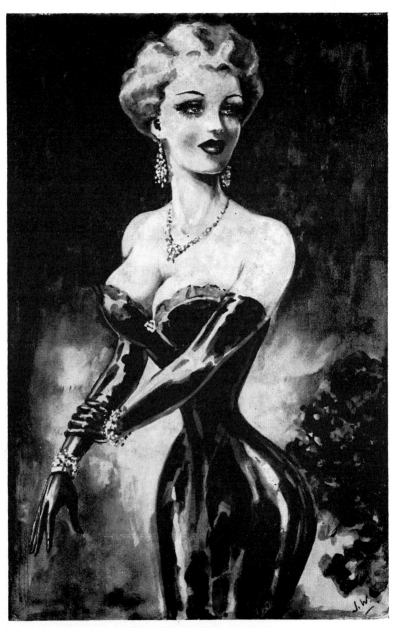

"Miss Wasp-Waist, 1953"

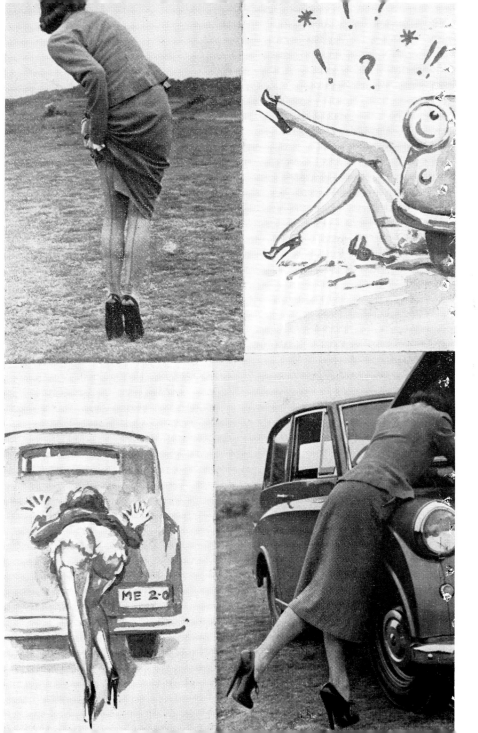

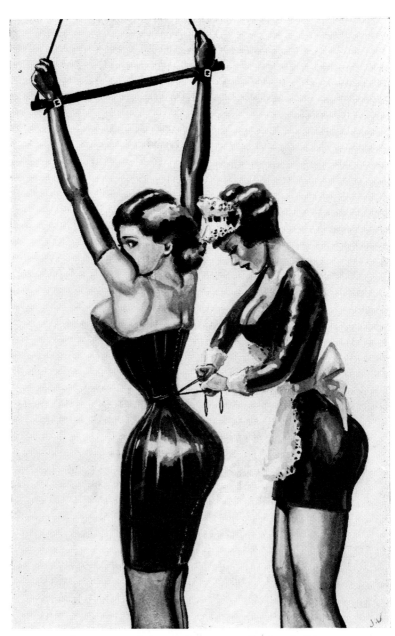

observe my fair one! *plenty of this —*

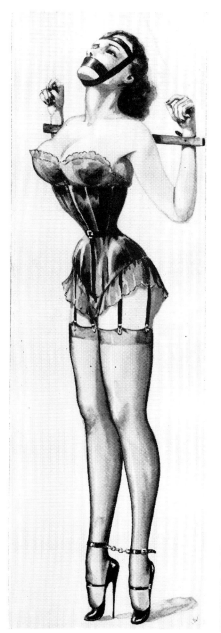

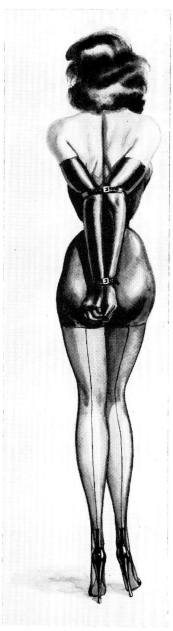

and lots of this — *and this —*

15

ON WITH THE MOTLEY!

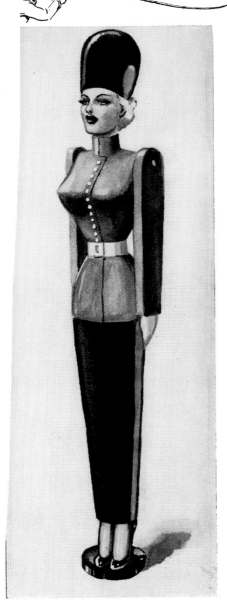

Wooden Soldier

P.B.I.

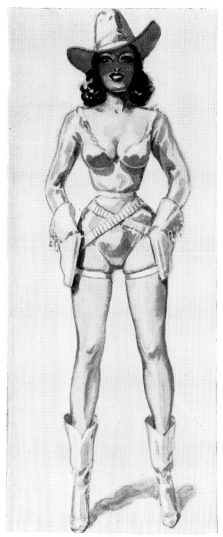

Arizona

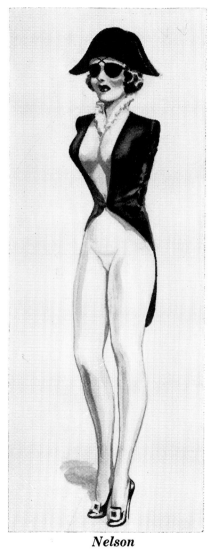

Nelson

MISS BIZARRE

If a fair maiden finds the light of her life reading *Bizarre,* she will realise that something is in the wind. The question is what? What must she do? What must she wear to please him? One false step and a beautiful romance may be loused up — but don't worry! We're right with you in your hour of crisis! Just leave it to Willie.

It is assumed that you are already an expert in wrestling, judo and boxing. Therefore if you are required to take the dominant role you will be able to cope with the situation, but it may be the other way about so you must appear very helpless and feminine.

He may like boots, so you wear one boot; long sheer stockings, so you display one on the other leg — held up tightly by at least six suspenders. Similarly you have a bloomer and fancy garter on one leg, and over it a pair of brief frilly scanties.

The extremely wasp-waisted corset of black kid has convenient rings to which shafts can be attached should you be required to serve as a girl pony; and the ring in the nose in this case is an excellent substitute for a bit to which the reins are attached.

Your makeup must be extreme, including a tattoo on your left shoulder, and you are drenched in perfume. You are covered in jewels but the bracelet on your right wrist is simply a pair of handcuffs. Your long hair, scarcely visible from the front (he may like it short) cascades down your back unbraided under your black gleaming rubber cape whose hood can be brought forward to cover the face (a la Blind Girl Fluff).

Having rigged yourself up in this ensemble you strap one arm tightly back at the waist. Then your head held high by the stiffly boned collar, your earrings brushing your shoulders, you pick up a riding quirt, and with the shackles on your ankles jangling, go and interrupt his reading.

Now we don't guarantee that this is going to be absolutely perfect. We may have overlooked something but at least it will show an enthusiastic desire to cooperate; and we present the idea with our best wishes for a prosperous and happy New Year.

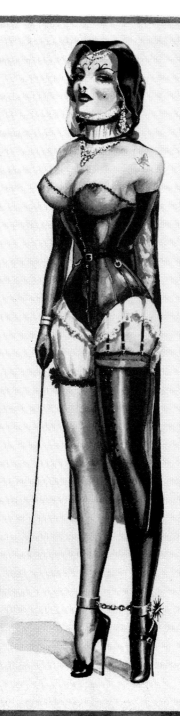

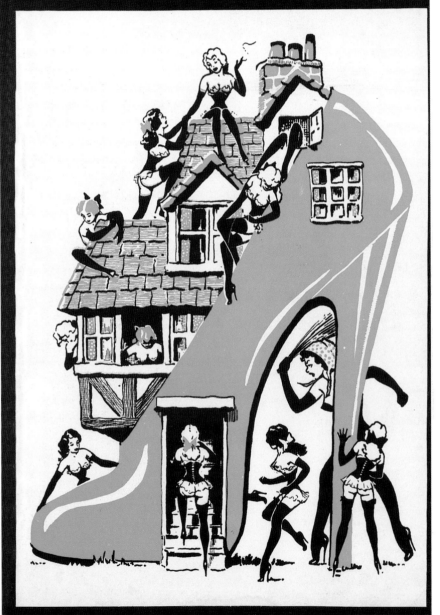

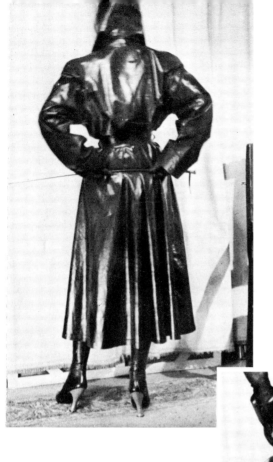

look out Noah!

here I come!

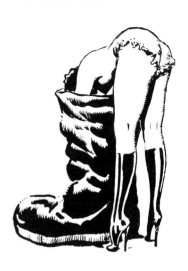

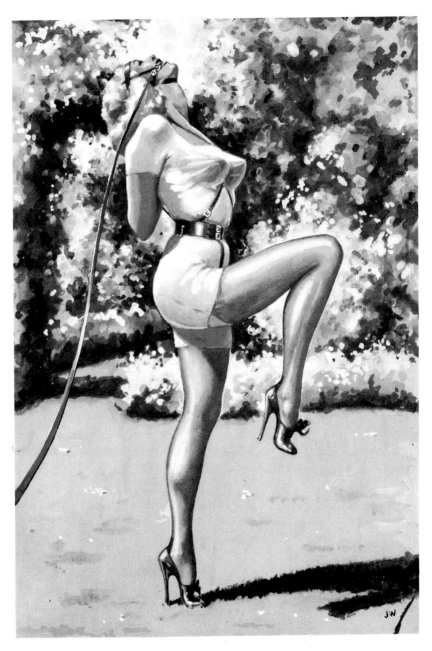

she was doing a very beautiful "high action" trot

Colonel Bloomer *Captain Cincher*

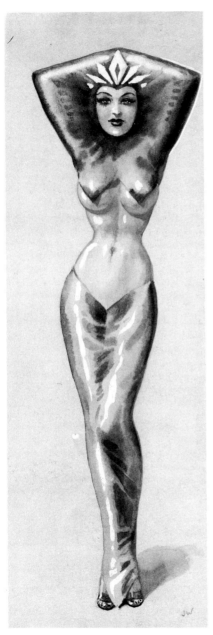

Miss Spaceship

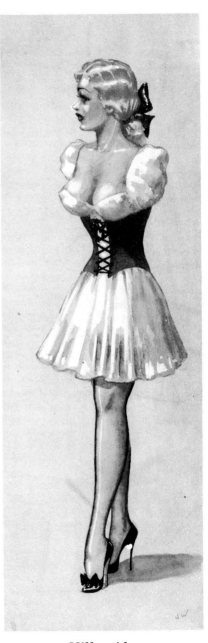

Milkmaid

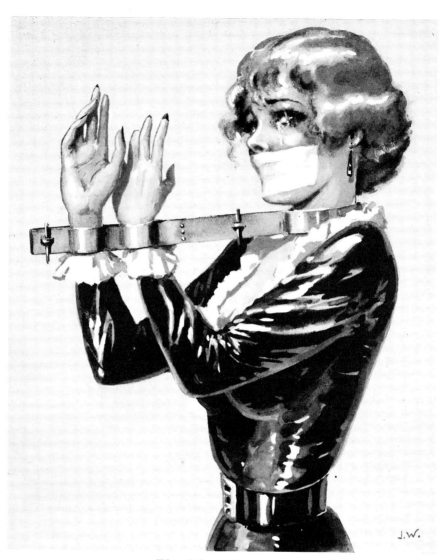

The Silent Piper

(dig that crazy axe!)

The "6" inch Heel ____

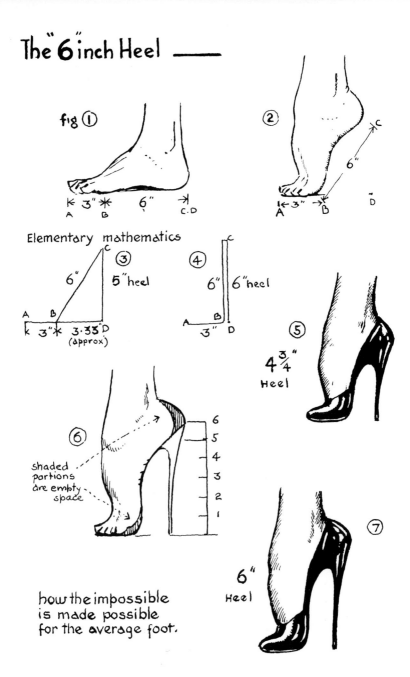

fig ①

②

6"

3"
A B C.D

I←3"→I
A B D

Elementary mathematics

③
6" 5" heel
A B
k 3" → 3.33 D
(approx)

④
6" 6" heel
A B
3" D

⑤
4¾"
Heel

⑥
shaded portions are empty space

6
5
4
3
2
1

how the impossible is made possible for the average foot.

⑦
6"
Heel

51

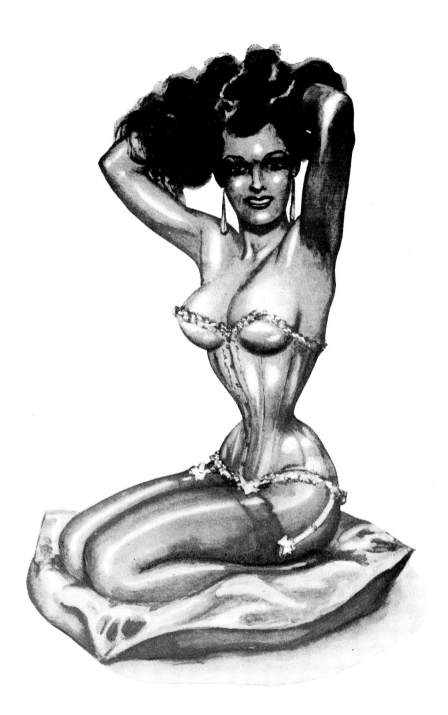

portion of "Colorado" stone. J. Willie expedition, 1953 A.D.

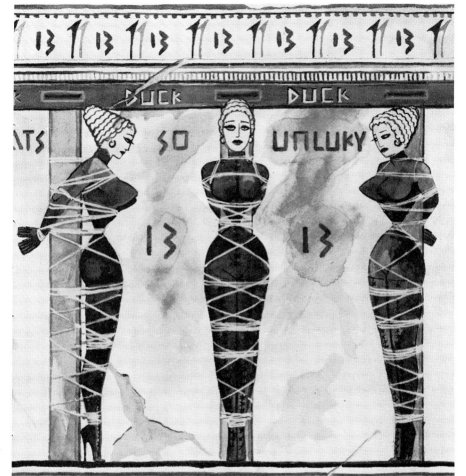

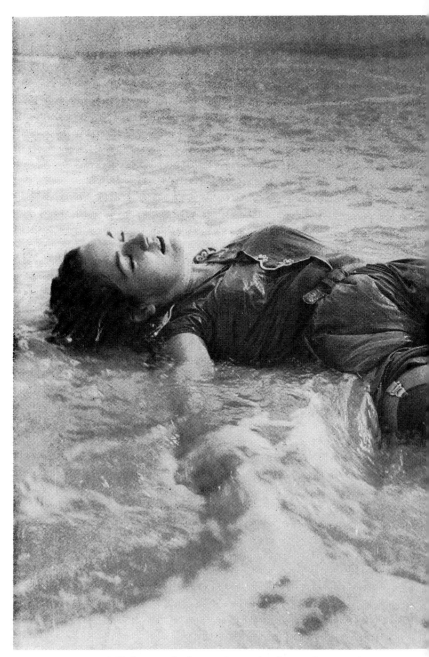

drifting an' dreaming—(and a trifle damp.)

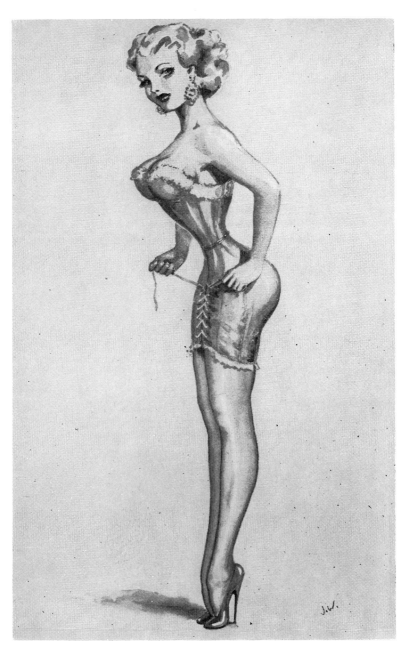

the Gibson Girl corset

for special occasions it's nylons by "Poinsettia"

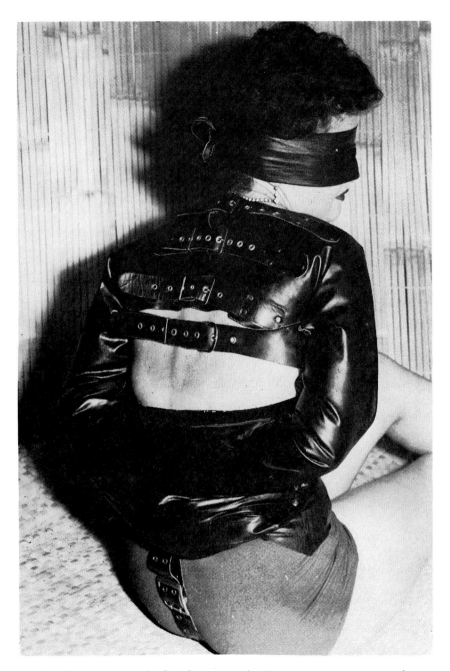

a leather straight jacket for peace in the home *photo from a reader*

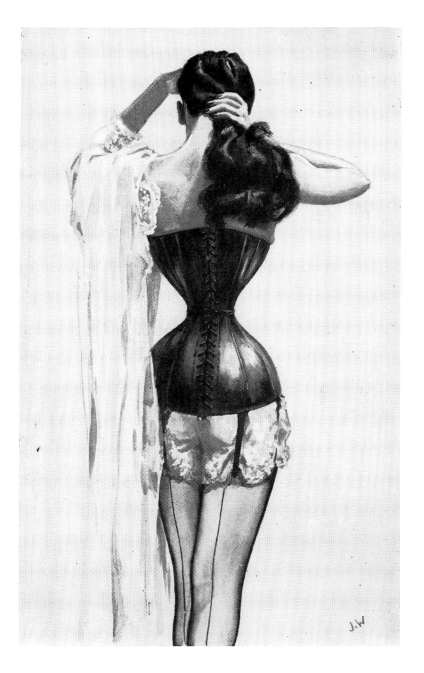

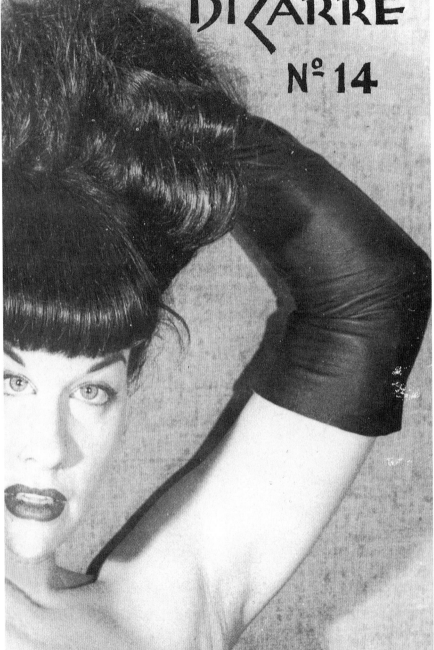

Bizarre

Nº 14

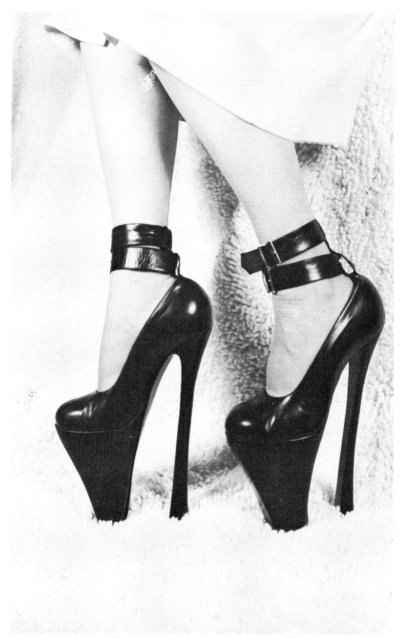

See Letter p. 55

Photo from U.C.

5″ platforms, 10″ heels

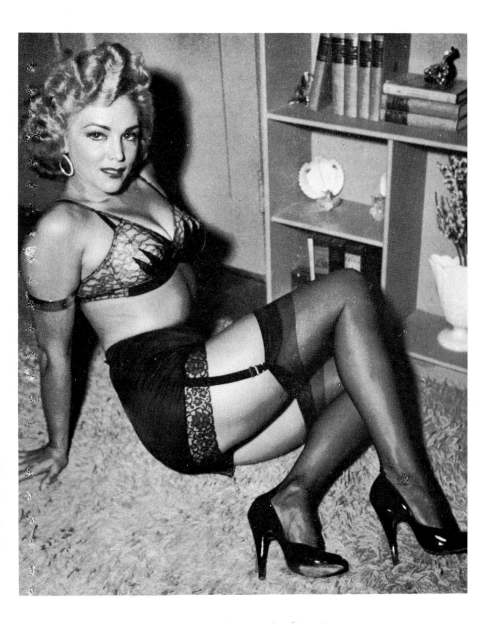

the modern trend in lingerie

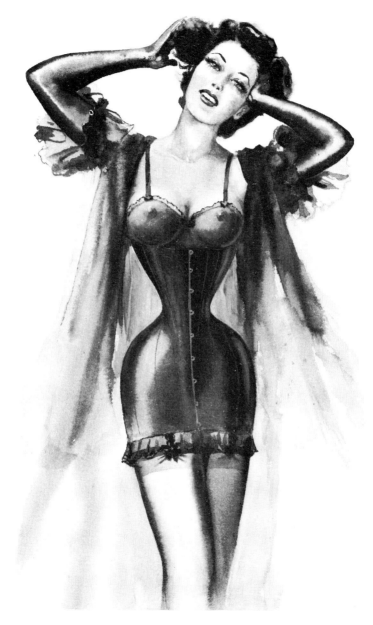

the black corset

Bizarre

Nº 15/16

CORRESPONDENCE ISSUE

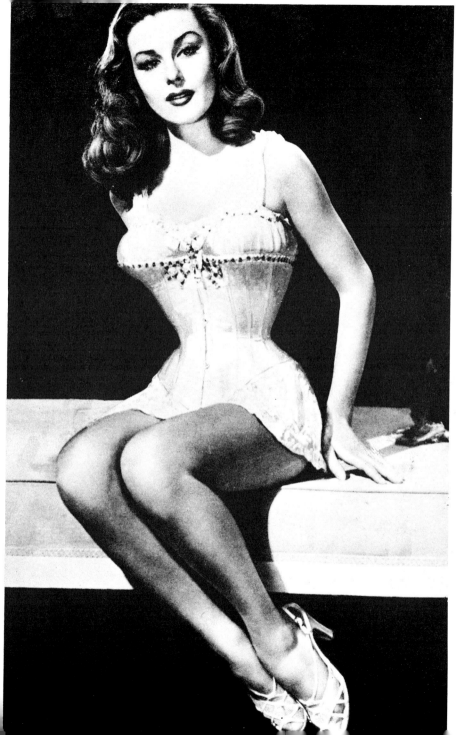

TIGHT SKIRTS
THIS YEAR
says fashion :~

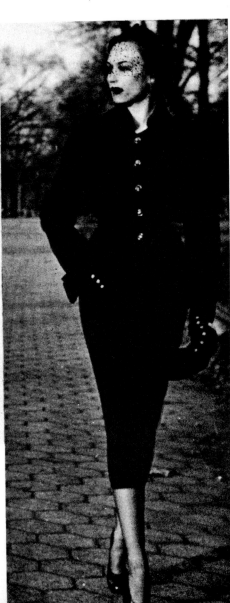

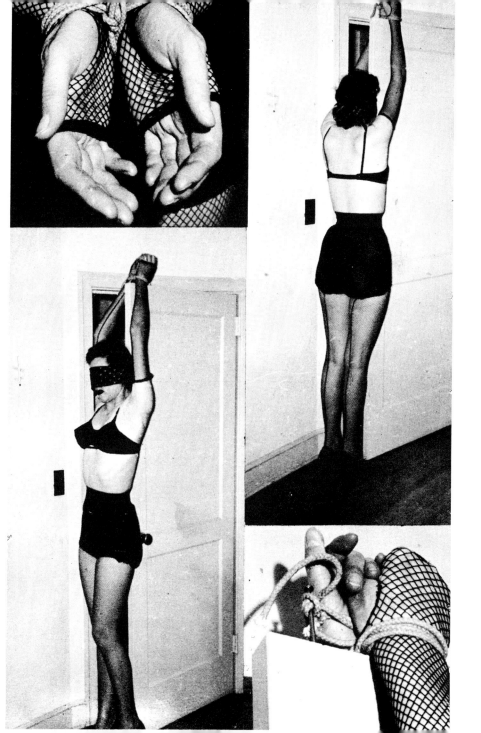

BiZARRE

Nº17

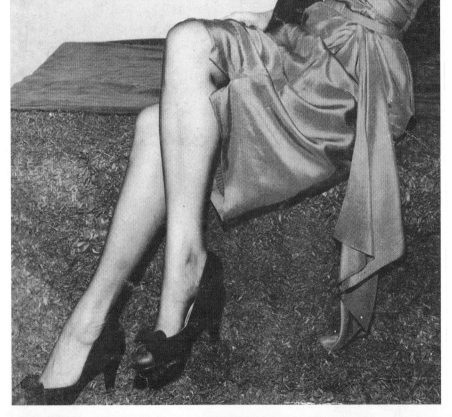

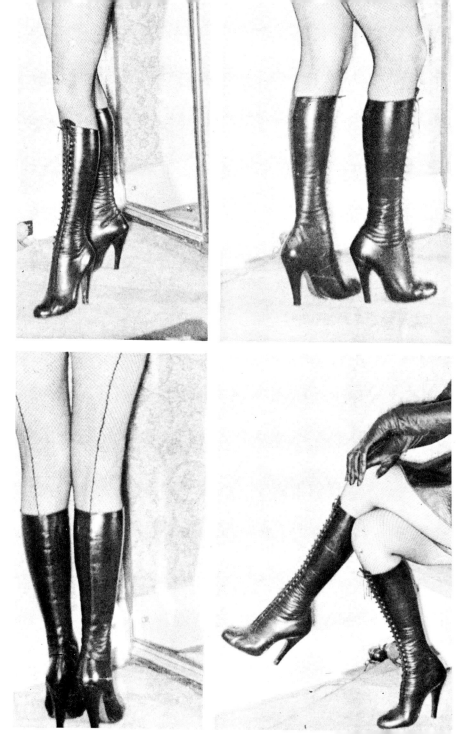

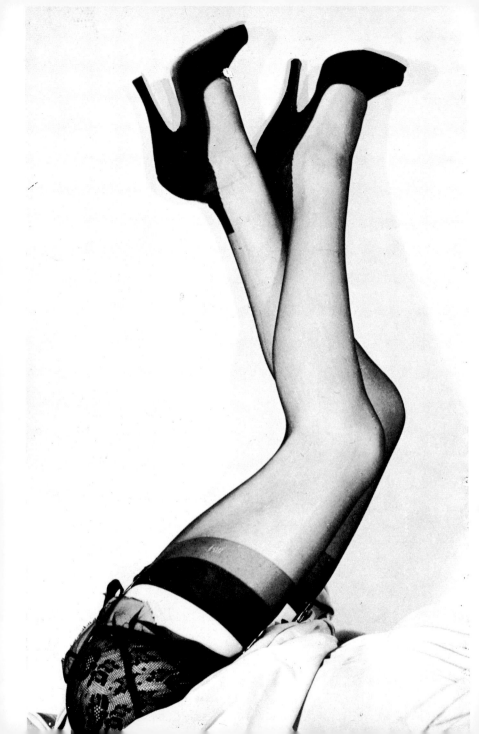

BiZARRE

N° 18

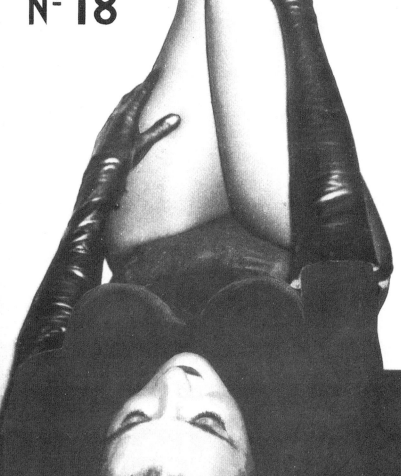

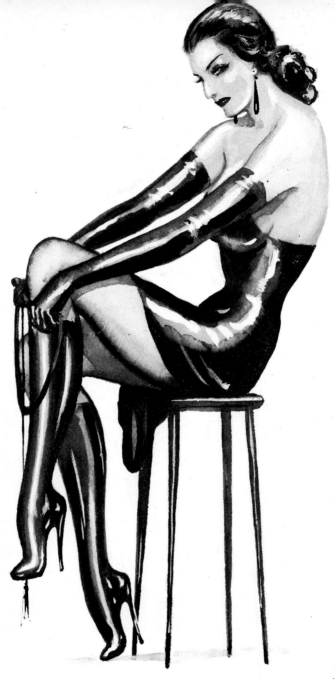

" ENTRE ACTE "

HAIR STYLE BY MYRTLE STULTZ

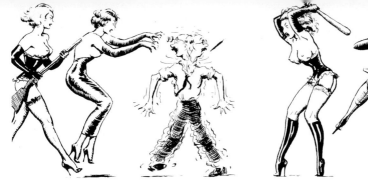

WHO'D BE AN EDITOR !

One fine sunny morning the Mailman brought us this letter.

Dear Sir:

Why don't you learn something about boots before you start showing pictures of them, and the things your artist draws are dreadful, so he can learn too.

On the perfect boot the gap between the lace holes should not be closed. When laced to the limit it should be at least 1½ inches open — 2 inches is ideal. If the lace holes meet the boot cannot be drawn tighter, but if there is a gap not only can the laces be tightened but they look tight.

Only by extreme tightness will the flesh bulge out at the top of the boot and between the laces — which is the most desirable and attractive feature.

Anyone who knows anything about the appeal of the knee-length boot knows that nothing is more beautiful than a heavily built foot and leg bulging, and obviously

squeezed into the boot, and laced with difficulty. By this means and no other is it possible to get the absolutely smooth tight fit without wrinkles which is so desirable.

Yours,

N.C,

Personally we always thought that a boot or a shoe should fit like a second skin, but we do our best to oblige the readers so when another reader sent us the photos you saw on Page 32 (No. 7) we thought everyone would be happy. Then we got the following letter.

Dear Editor:

I have enjoyed your magazine immensely, ever since I first saw it, and now for the first time I am disgusted with a picture in Bizarre. I never thought this would happen. Needless to say that I am a high heel fan, an admirer of beauty of every kind, leaning to the bizarre. High heels are an accessory of the natural beauty of feminine legs and feet,

keeping the muscles under tension.

You published a number of exquisite photographs of models with high boots and high heels, three of them in volume 3 (pages 1, 25/26, 27), one on page 21 in volume 6 and one of special beauty and decency on pages 34/35 in volume 7. In all these the boots, obviously made by a true craftsman, fitted perfectly, the laces meeting and the top of the boot merging in to the leg smoothly as a boot should.

But, dear editor, how badly could you slip in your otherwise excellent good taste, just two pages away from the beautiful center spread picture in volume 7, is the dreadful picture collection on page 32. In my opinion this is the most vulgar and disgusting display of boots with high heels I have seen. It certainly has no place in a high class publication like Bizarre. In these pictures there is no beauty, nothing bizarre, it is just a display of the bulging legs and fat feet of a 400-pound lady in shoes that belong to a gracious woman.

I know well, that the tastes are different, that the orientals, (in no way all of them), like their women fat, in Farouk proportions, if possible. But in the Western world, for more than 2000 years, since the classic art flourished in old Greece, and in the Americas, such overweight and such ill fit-

ting boots as your model displays, are considered ugly.

If you borrow a female hippopotamus from the zoo and put her four feet in high heeled boots, you would have a nicer picture, more decent and more bizarre than the one you printed.

Yours truly,

G.K.

— and then almost by the same mail this:

Dear Sir:

I'm glad to see that you pay some attention to what your readers tell you. The boots shown on page 32 of your excellent issue No. 7 are perfection.

Yours,

N.C.

By this time we were only swaying gently and gasping for air — until we got the following letter — from someone with a simple fixation of purpose.

Deár Sir;

Why do you not print more pictures of Girls in Boots and High Heel Boots as I love Boot pictures.

Cousin Betty says, She likes Boots too but she and I agree that girls tied up in issue after issue is very silly.

You could get more readers If you cut out the tyed up's of girls and printed more Boot Pictures and then some more Boot pictures.

Why cant we Have more photos of the girl in boots and black rid-

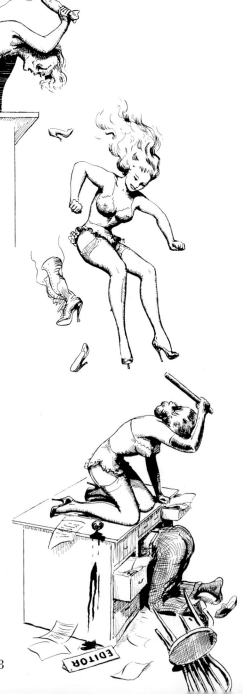

ing brechees from No. 2. These were High Heel Riding Boots and are the most beautiful Boots better looking than the Laced or Button ones.

Betty wants to know where she can write to Achchelles the Boot-Maker and If he has a catalog etc Prices of Boots like these.

Why Do you not Publish Bizarre more often. Did you ever hear of London Life they Published Boot Photos too and stories.

Would J.W. be interested In my C story about a Princess and Prince (its a Womens World) who like to wear Boots I will sell it to him for 5c a word and include the rights to republish etc But Not rights to Make into a Movie or Stage Play this would cost 10c a word additional.

The reason we buy your Magazine is because of the Girls in boots why not a Girl in boots on the next cover.

<div style="text-align:center">

Very truly yours,
R.E.H.

</div>

(to which we can only answer — "Well why not send in the b . . . story !" . . . Ed)

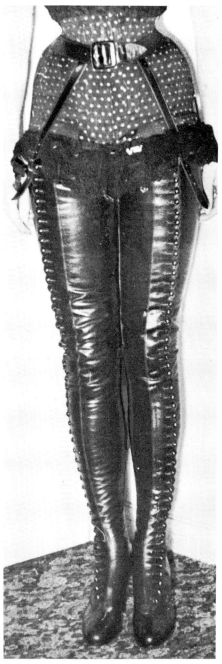

NOW WHAT WOULD SOLOMON DO?

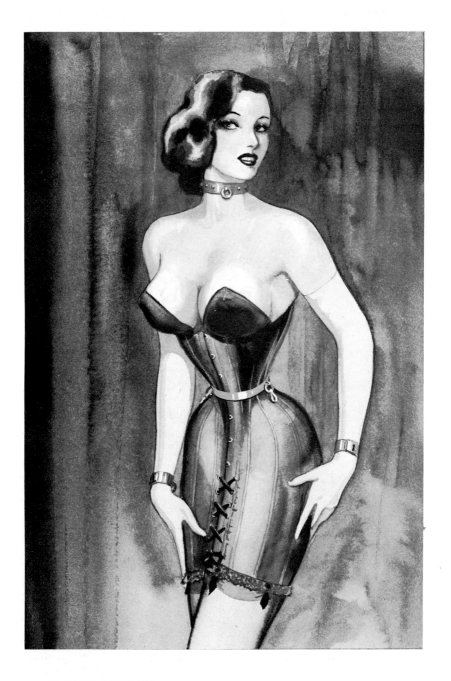

TRAINING CORSET WITH SAFETY BELT

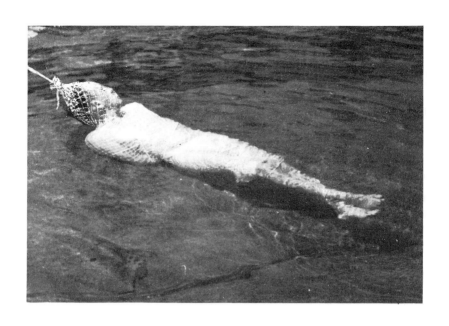

UHUH ! — NOW WHAT A MESH YOU'RE IN !

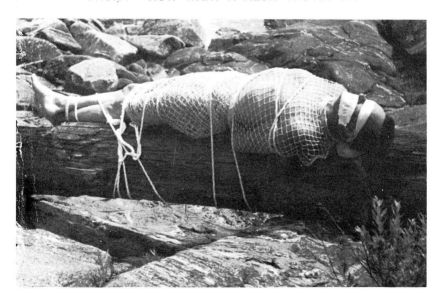

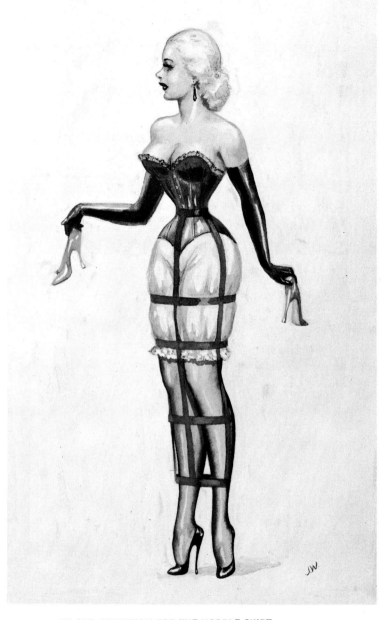

AN OLD INVENTION FOR THE HOBBLE SKIRT —

TO TAKE THE STRAIN OFF THE SKIRT ITSELF

the single shoe —

photo from D.

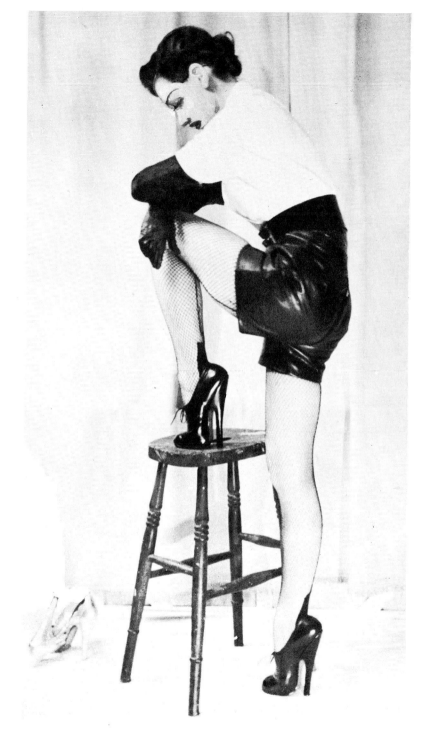

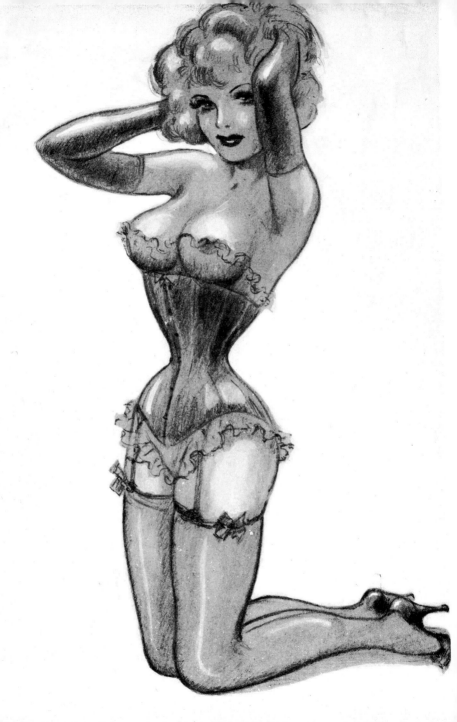

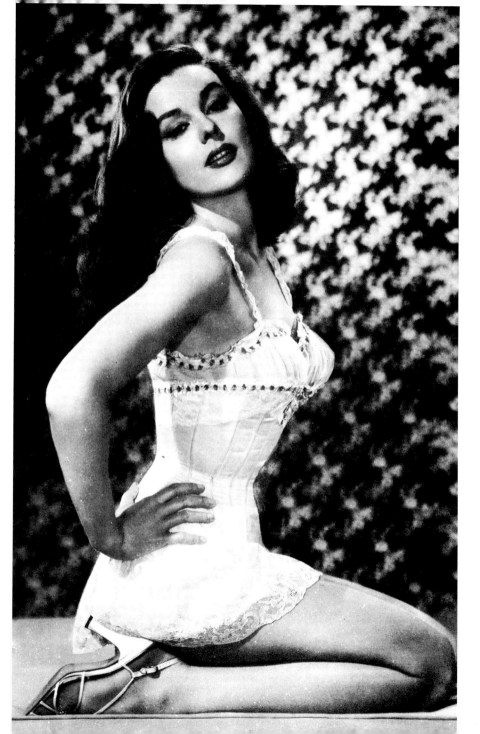

BiZARRE

N° 20

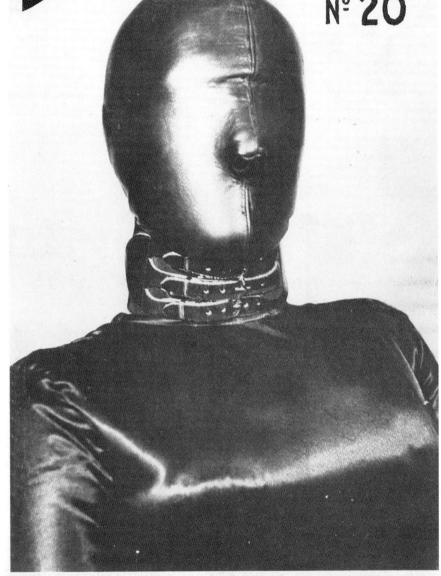

The Judgement of Paris

(corset division)

No. 1 VERA ELLEN

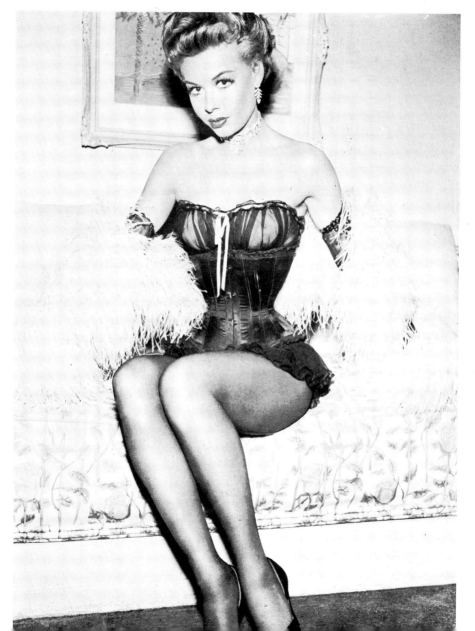

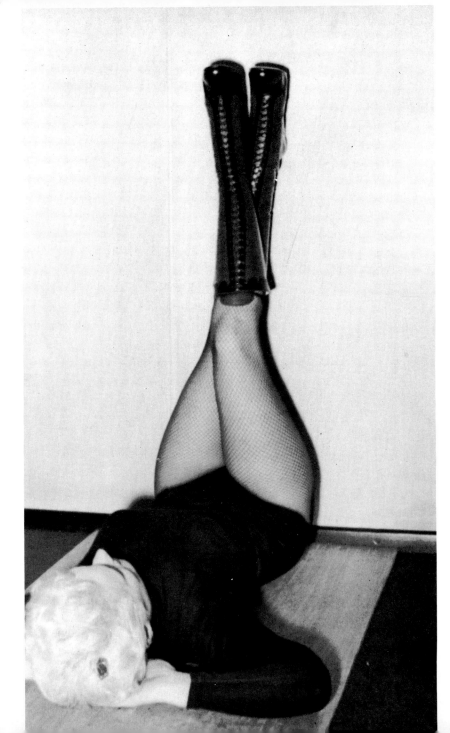

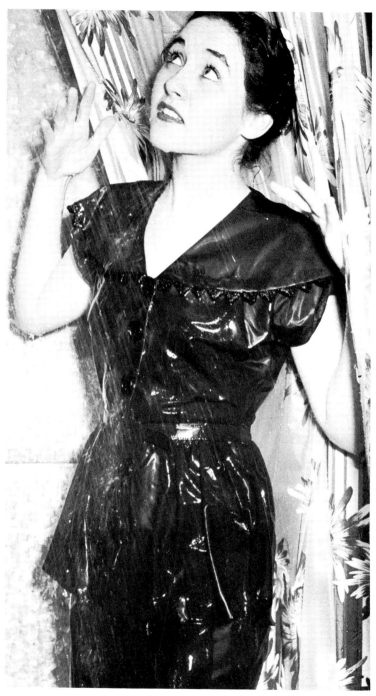

the shower-bath

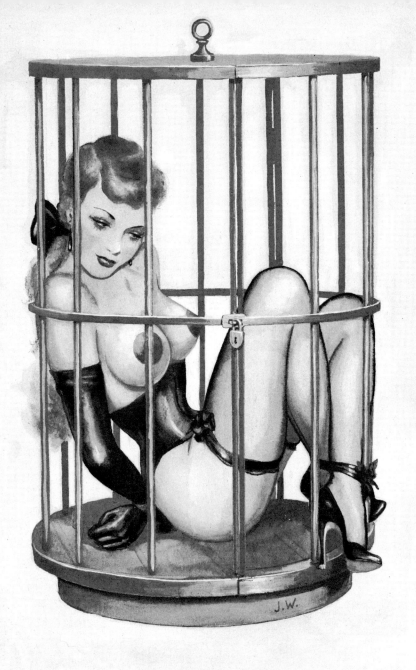

" PRETTY POLLY "

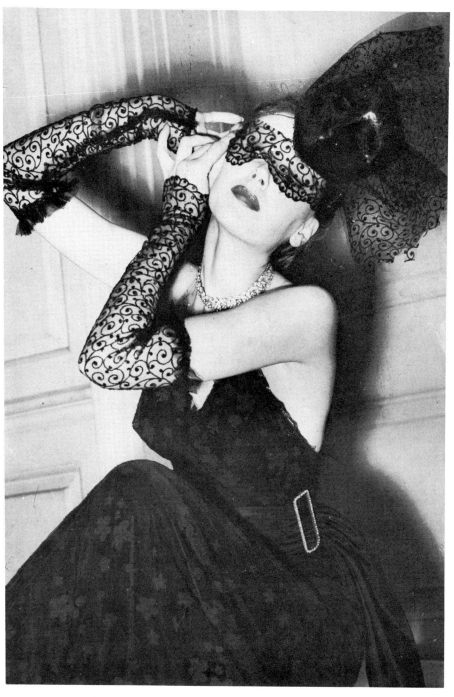

original ? — bizarre ? — but how attractive !

BiZARRE

21
CONTENTS
CORRESPONDENCE

PATTERN FOR MODERN WASP CORSET.

Half corset shown. Repeat when cutting.

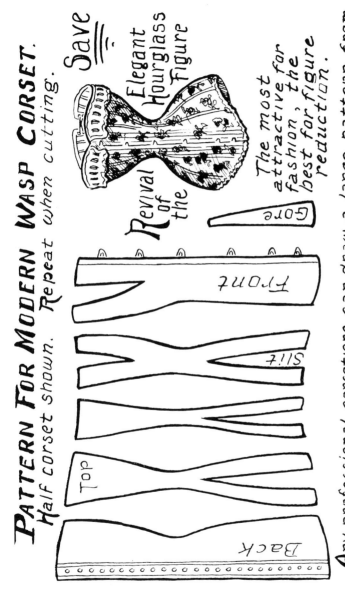

Save

Revival of the

Elegant Hourglass Figure

The most attractive for fashion, the best for figure reduction.

Gore

Front

Side

Top

Back

Any professional corsetiere can draw a large pattern from the above. This corset is as easily made as any boned corset. Vary measurements with wearer. Use firm stock materials but no elastic. At least 7 or 8 steels should be sewn in each half, top to bottom. For wasp shape bend steels in at sides of waist and round them out over hips. Use long lacers. Slits are for gores, important for stylish curves. A simple short corset can be made with a 12 inch front clasp.

 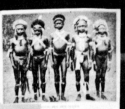

"Ibitoe"

IS THERE AN IBITOE IN THE CROWD?

IBITOE IS THE NAME GIVEN A NEW GUINEA BOY OF THE RORO, WAIMA, OR ELEMA TRIBE WHEN HE HAS BEEN INITIATED AND HE HAS ASSUMED WEARING THE *ITABURI*, OR TIGHT WAISTBAND.

At the time when the women of the tribe begin their life of druggery and submittance, the *ibitoe* is a dandy, a slave of fashion, whose crowning achievement is to obtain as small a wasp-waist as possible. When a Roro boy enters manhood, his ears and nose are pierced and his father asks his maternal uncle, "suffer now that my son assume the *itaburi*"; the uncle places the *itaburi* on the boy and he is then subjected to further "restrictions and disabilities." (C. G. Seligmann, *The Melanesians of British New Guinea*)

John Foster Fraser in *Quaint Subjects of the King* writes, "when a Papuan boy gets to the age at which an English boy begins thinking about taking to stand-up collars, instead of encasing his neck in a rampart of stiff linen, he crushes his waist into a wooden belt so tight that his ribs protrude over it like the chest of a pouter pigeon. The belt terminates at the back in a kind of tail which

trails upon the ground, and the more wasp-like his waist, the more airs the boy gives himself. When he has assumed this wooden belt he is called *ibitoe*, and becomes entitled to all privileges of a full-grown man (including the choice and domination of a woman.)"

The material of the *itaburi* varies from tribe to tribe and is usually beaten bark (wood), hide, or boned snake skin. Tight arm and leg bands, a high shell collar, pierced ears and a pierced and enlarged septum, or slits in the nostrils, complete the beauty of the *ibitoe*. It is difficult to find any accurate information on the size of an *ibitoe's* waist, but one French naturalist, who claims to have cut by force an *itaburi* from a full-grown *ibitoe*, gives the measurement of 20 inches on the inside of the belt. In recent times the assumption of the *itaburi* has practically ceased. Civilization has enlightened the savage! In the times prior to World War II, the

(2) First Itaburi

(1) Embossing: First Itaburi

itaburi was assumed at about the age of 15 and was worn for life; the only occasion for removing the *itaburi* was to replace it with a tighter one. As the young *ibitoe* became adjusted to the *itaburi*, he could walk, run, hunt, and do all other strenuous physical activity without removing it. Those youth of New Guinea who still wear the *itaburi*, wear it only for about a week during the initiation and on special occasions.

I first saw a picture of an *ibitoe* when I was 15; the sight of the boy-about-to-fall-in-two made my pulse jump. He was practically cut in half by a solid black belt 4 inches wide. The caption read: This Melanesian youth from one of the islands near New Guinea must be the talk of his village. For above all things, his people admire small waists and well-spiked noses.

(Note to Editor: This picture appeared in Volume "P", under "Pacific Islands", Compton's Pictured Encyclopedia, first post-W. W. II edition. Another good picture of five *ibitoe* on initiation day is to be found in Loomis Havemeyer's *Ethnography;* this photo is courtesy of Dr. A. C. Haddon.) Immediately after seeing this picture, I had the strong desire to emulate the boy with the wasp-waist. I began my career as an *ibitoe* several weeks later when I found an old-fashioned, heavy leather, ladies' belt in a box of old cloths. This belt was 2 inches wide with a double-pronged buckle. It had slit-like notches on both sides for the entire length and could be decreased to zero circumference if desired. I sucked in my stomach, stretched, and pulled the belt in as tight as possible over my bare

skin. I felt bisected and especially strange when I moved or walked. After several hours, I felt a pleasant lightness, though I still had difficulty moving about and doing simple tasks. I wore this belt as tight as I could pull it for a while each day from that day on.

After several months, I became adjusted to wearing the *itaburi* and I could do all sorts of bends, squats, and the like without losing my balance. At first I could only wear the *itaburi* for several hours, or even less if I moved around a great deal. Wearing the *itaburi* is unlike wearing a tight corset; the edges are not padded or conical and ones full weight rests or presses on them. Even when well powdered or greased, these edges soon feel like two hot wires, one around your pouting chest, the other around your hips. I tried wearing the *itaburi* over various items of clothing, but this never gave the same effect as on the bare skin; over clothing, the *itaburi* would suddenly move to a slightly different position and my whole body would have to adjust to the change.

With my first several *itaburi*, I used to pull my waist in to 16 inches. Sometimes I would wear them for two days without touching them; sometimes I would pad the indentation and take a long walk in them. I gradually developed tough, calloused skin about my waist and the edges of the *itaburi* did not cut or burn any longer. An interesting side effect of my first *itaburi* can be noticed in photograph one; because this belt was full of notches and slits, it left a long-lasting embossed pattern around my waist after it was removed. In photograph two, a very old picture, I am wearing this first *itaburi*.

When I was inducted into the Army in 1952, my 5′ 9″ had a normal waist measurement of 22½ inches, to the amazement of the medical officers and the confusion of the quartermaster's people. During this two years service, a horrible thing happened; the *ibitoe* had to resign temporarily. I could not belt properly and on my release my waist had expanded to a miserable 32 inches! Since my release, I have become the *ibitoe* again and have managed to reduce this to a more comfortable 24 inches. I am also wearing a number of new *itaburi;* I have specially designed these and made them of heavy leather. They vary in width from 2 to 7 inches and in minimum circumference from 21 to 17 inches; some of these *itaburi* wrap around, some fasten with straps, and some are like vises with built-in screws. In photographs 3 and 4, I am wearing my

current favorite. It is 3½ inches wide and is adjusted to its minimum 19 inches. Incidently, "One Covered All Over" of Number 17 should appreciate the tattooing; this kind of design goes well on the *ibitoe*. Photograph 5 is a recent side view of *Ibitoe* minus *itaburi;* notice the structure of the ribs as seen in the shadow in this picture.

I have a stuffed album of such pictures and it has been very hard for me to decide which few to enclose with this letter. If your readers take kindly to the idea of the *ibitoe*, I'll send more for following issues. I have many pictures of Ibitoe exercising as well as photos of Ibitoe's favorite accessories and party costumes; Ibitoe thinks they are all very bizarre and interesting and would appreciate comments.

Yours for smaller waists,
IBITOE

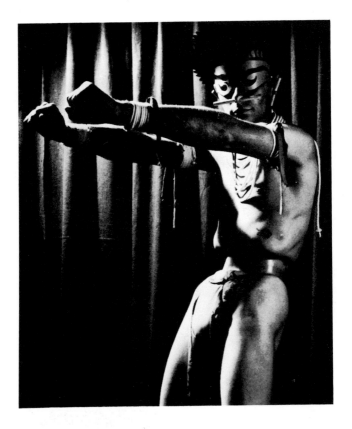

(3) IBI'S DANCE

BiZARRE

**TWENTY
TWO**

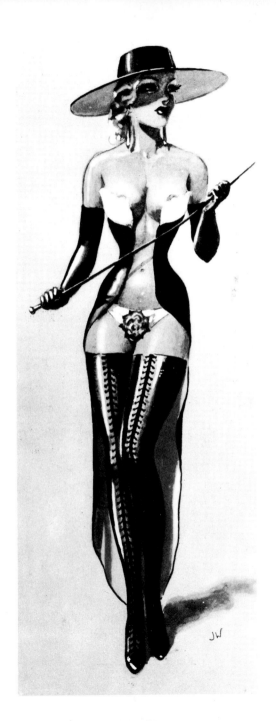

PYRRHIC VICTORY

Fig. 1

Before After

Fig. 2

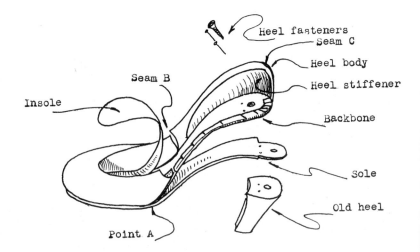

for slaves of fashion

theatrical footwear

WELCOME HOME

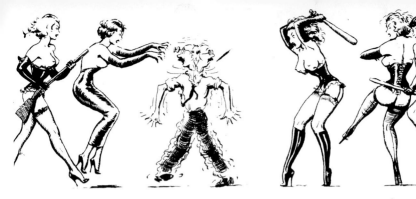

WHO'D BE AN EDITOR *!*

SLINGS AND ARROWS

This is a "Reader's Issue"—

Even the editorial was written by proxy — and it mirrors our reflections of this season.

In the composition, we aimed to fill direct requests and still be representative of all. 'Twasn't easy, but we think we've hit a fair target.

With this bow, we don't expect applause, but only the over-ripe apple of screaming Charlie letters, "What happened to OUR group? You COMPLETELY forgot OUR group."

Alright, Charlie — we'll get your group next time, honest canuck injun. In the meantime, we appreciate the grouching reminder; it keeps us tempered and honed.

One other thing, Charlie — *our mailbag is never ignored* — The letters are interesting and we read them all with more than a bleary editorial eye, but we can answer only a small fraction of them. If we don't use that new idea of yours, kiddo, it's either a duplication, dubious, or it's TOO good. You know what we mean, Charlie . . . You know . . . Where did you dig up that stuff anyway? You haven't led that many lives. And those people you know!! Wow-Whee!!

Keep'm coming down the middle, Charlie, — Yours is a good group.

Sincerely,

ED — Montreal

5

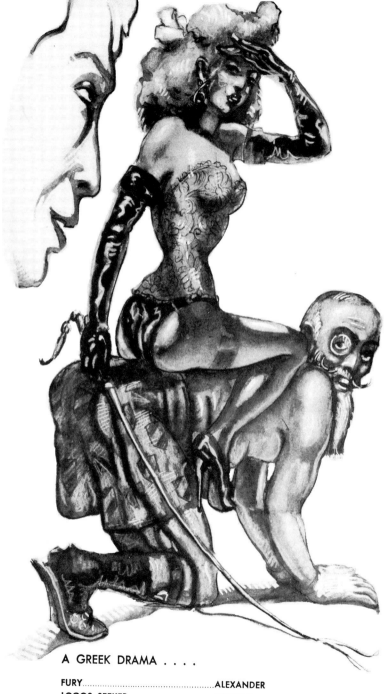

A GREEK DRAMA

FURY..........................ALEXANDER
LOGOS SEEKER.............BARSINE
BUCEPHALUS..................ARISTOTLE

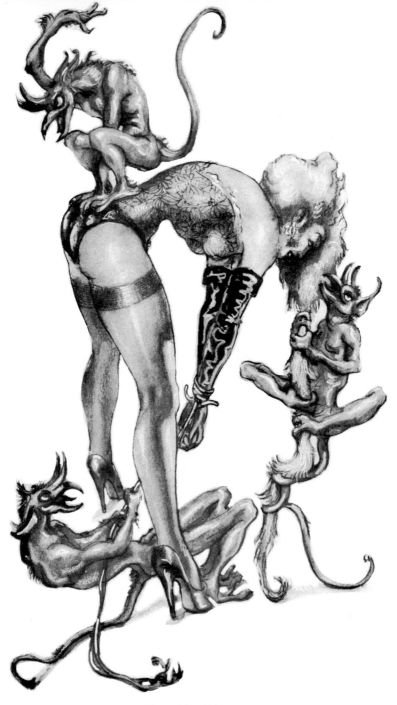

TOO MUCH

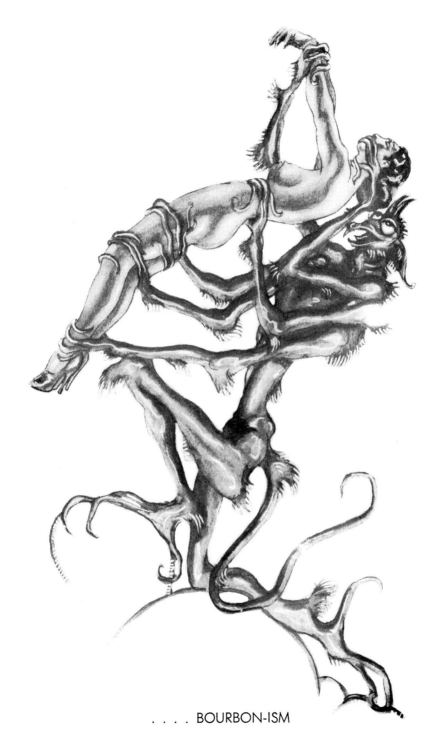

. . . . BOURBON-ISM

BÉ BÉ

SKIRTS ARE GETTING SHORTER

(And for good reason . . . See page 47)

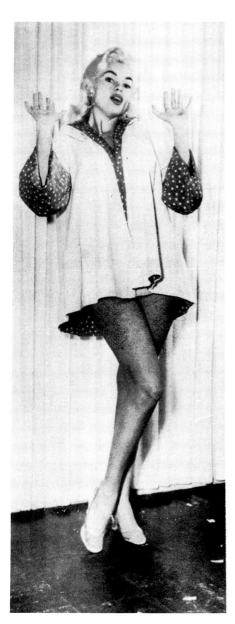
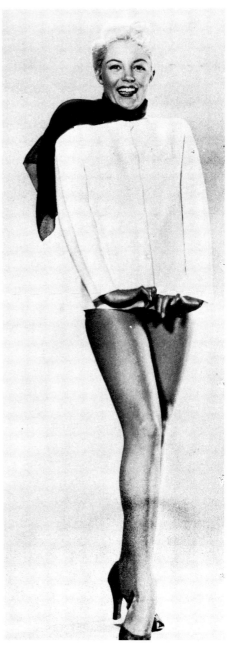

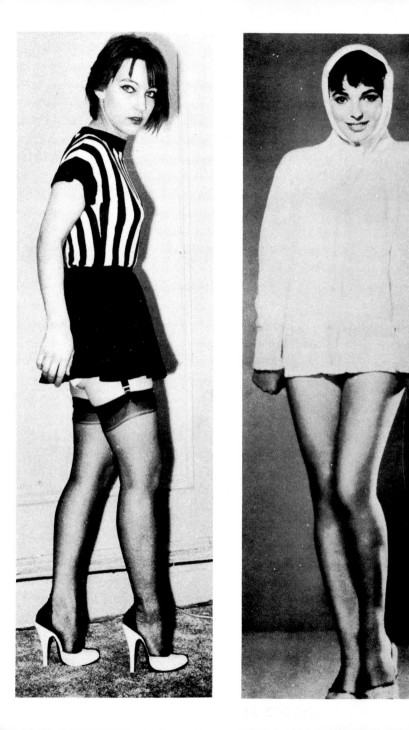

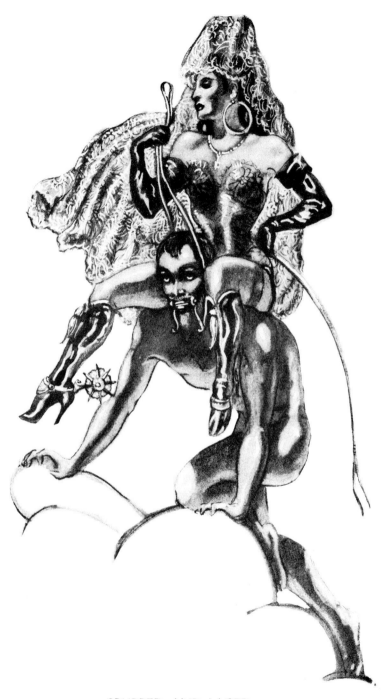

SPURRED AND LACED

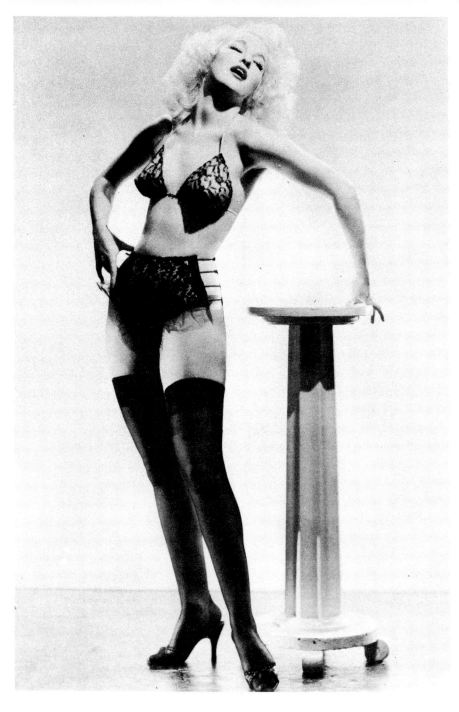

LINGERIE FOR THE WARM DAZE

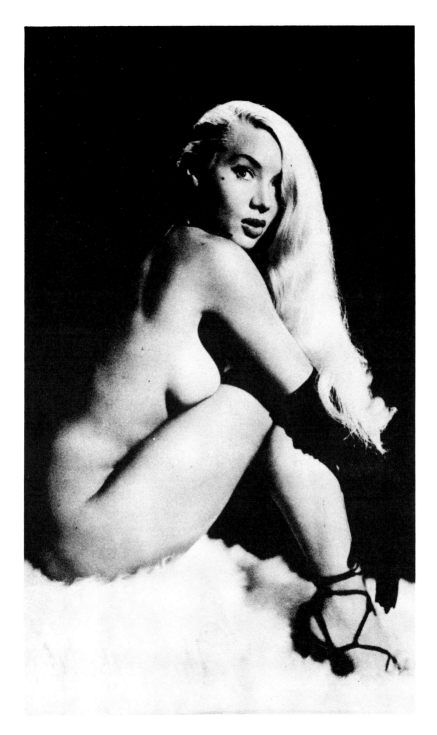

BIZARRE

Nº 24

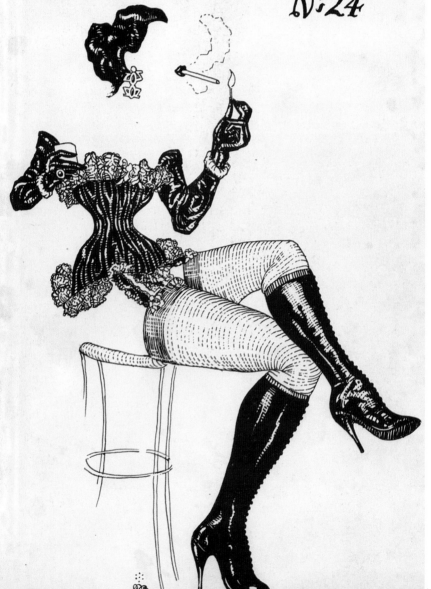

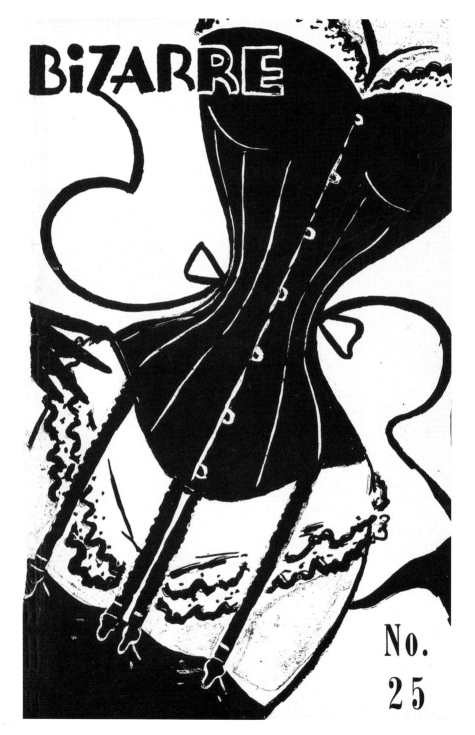

BiZARRE

No.
25

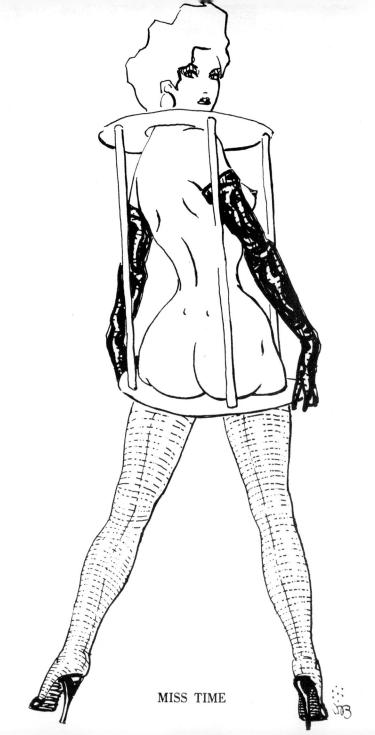

MISS TIME

and NOW!

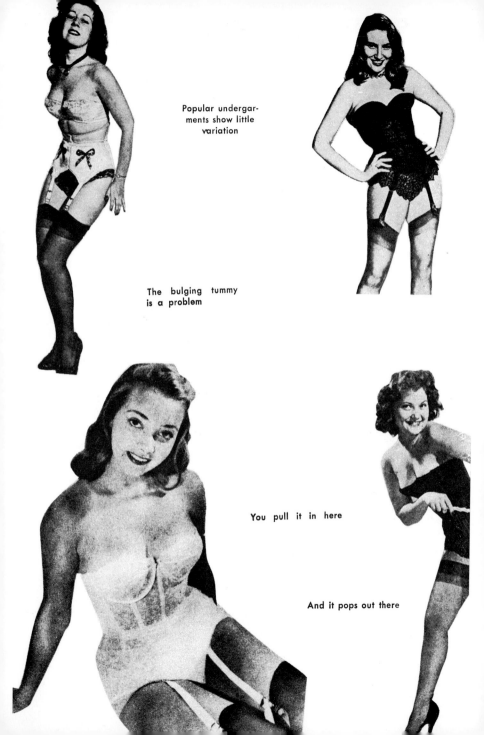

Popular undergar-
ments show little
variation

The bulging tummy
is a problem

You pull it in here

And it pops out there

BIZARRE

No. 26

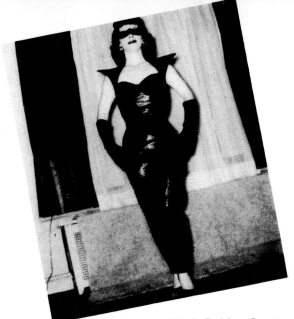

Black Rubber Lamé
Leather Gloves
Gold Metal Mask

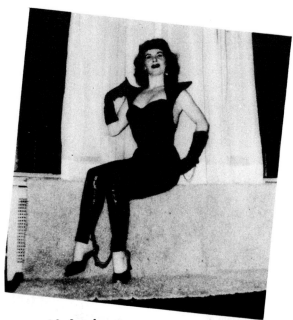

with Jewelry

Leath
Elastic
Elastic
Leather (

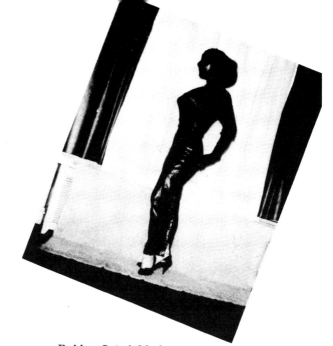

Rubber Suit & Mask
Elastic Sweater

rt
ngs
ter
& Belt
G.

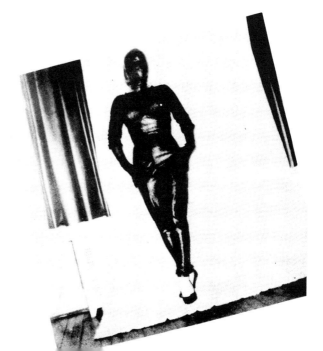

"Buy them all and add some pleasure to your life."

Art Now
Eds. Burkhard Riemschneider,
Uta Grosenick

Art. The 15th Century
Rose-Marie and Rainer Hagen

Art. The 16th Century
Rose-Marie and Rainer Hagen

Atget's Paris
Ed. Hans Christian Adam

Best of Bizarre
Ed. Eric Kroll

Karl Blossfeldt
Ed. Hans Christian Adam

Chairs
Charlotte & Peter Fiell

Classic Rock Covers
Michael Ochs

Description of Egypt
Ed. Gilles Néret

Design of the 20th Century
Charlotte & Peter Fiell

Dessous
Lingerie as Erotic Weapon
Gilles Néret

Encyclopaedia Anatomica
Museo La Specola
Florence

Erotica 17th–18th Century
From Rembrandt to Fragonard
Gilles Néret

Erotica 19th Century
From Courbet to Gauguin
Gilles Néret

Erotica 20th Century, Vol. I
From Rodin to Picasso
Gilles Néret

Erotica 20th Century, Vol. II
From Dalí to Crumb
Gilles Néret

The Garden at Eichstätt
Basilius Besler

Indian Style
Ed. Angelika Taschen

London Style
Ed. Angelika Taschen

Male Nudes
David Leddick

Man Ray
Ed. Manfred Heiting

Native Americans
Edward S. Curtis
Ed. Hans Christian Adam

Paris-Hollywood.
Serge Jacques
Ed. Gilles Néret

20th Century Photography
Museum Ludwig Cologne

Pin-Ups
Ed. Burkhard Riemschneider

Giovanni Battista Piranesi
Luigi Ficacci

Redouté's Roses
Pierre-Joseph Redouté

Robots and Spaceships
Ed. Teruhisa Kitahara

Eric Stanton
Reunion in Ropes & Other Stories
Ed. Burkhard Riemschneider

Eric Stanton
She Dominates All & Other Stories
Ed. Burkhard Riemschneider

Tattoos
Ed. Henk Schiffmacher

Edward Weston
Ed. Manfred Heiting

www.taschen.com

ICONS